HOW TO DRAW
SCI-FI UTOPIAS
AND DYSTOPIAS

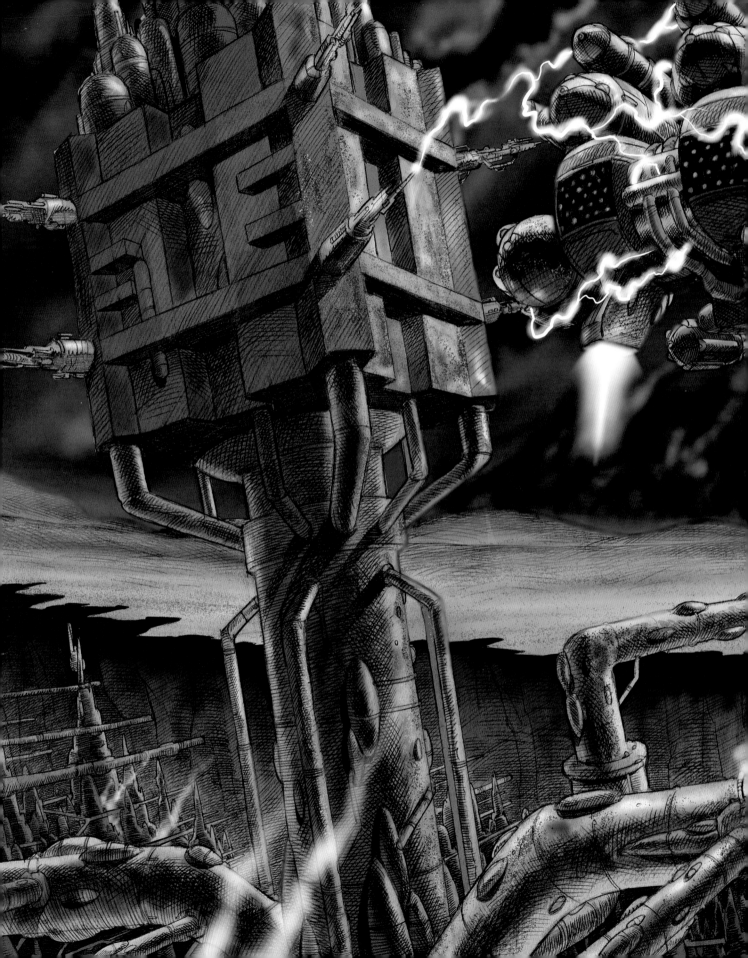

HOW TO DRAW
SCI-FI UTOPIAS
AND DYSTOPIAS

CREATE THE FUTURISTIC HUMANS, ALIENS, ROBOTS, VEHICLES, AND CITIES OF YOUR DREAMS AND NIGHTMARES

PRENTIS ROLLINS

𝕄 MONACELLI STUDIO

Published in the United States by MONACELLI STUDIO, an imprint of
THE MONACELLI PRESS

Library of Congress Cataloging-in-Publication Data

Names: Rollins, Prentis, author.
Title: How to draw sci-fi utopias and dystopias : create the futuristic
 humans, aliens, robots, vehicles, and cities of your dreams and
 nightmares / Prentis Rollins.
Description: First Edition. | New York : Monacelli Studio, 2016.
Identifiers: LCCN 2016015229 | ISBN 9781580934466 (paperback)
Subjects: LCSH: Science fiction in art. | Drawing–Technique. | BISAC:
 ART / Techniques / Drawing. | COMICS & GRAPHIC NOVELS /
 Science Fiction.
Classification: LCC NC825.S34 R65 2016 | DDC 741.2–dc23
LC record available at https://lccn.loc.gov/2016015229

ISBN 978-1-58093-446-6

Printed in China

Design by JENNIFER K. BEAL DAVIS
Cover design by JENNIFER K. BEAL DAVIS
Cover illustrations by PRENTIS ROLLINS

10 9 8 7 6 5 4 3 2 1

First Edition

MONACELLI STUDIO
The Monacelli Press
236 West 27th Street
New York, New York 10001

www.monacellipress.com

FOR MY CHILDREN—SCOTIA, DAGNY, AND LEE—AND
MY WIFE, JACKIE, WITH ALL MY LOVE.

ACKNOWLEDGMENTS

All of the artwork in this volume was created between November 2014 and
November 2015. Many thanks to my editors: Victoria Craven, for giving me
the opportunity, and Marian Appellof, for her fine suggestions and meticu-
lous eye.

Thanks also to the makers of the films from which images are used
in this book. All of these images are reproduced in accordance with the
United States Fair Use Doctrine.

CONTENTS

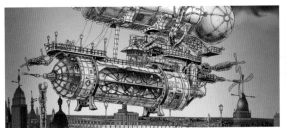

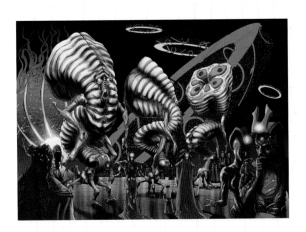

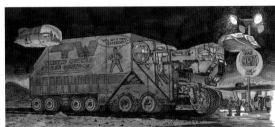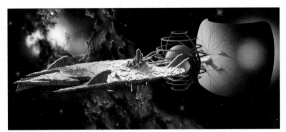

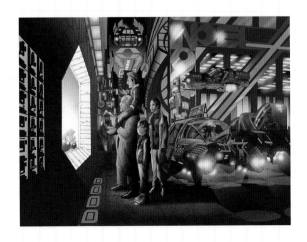

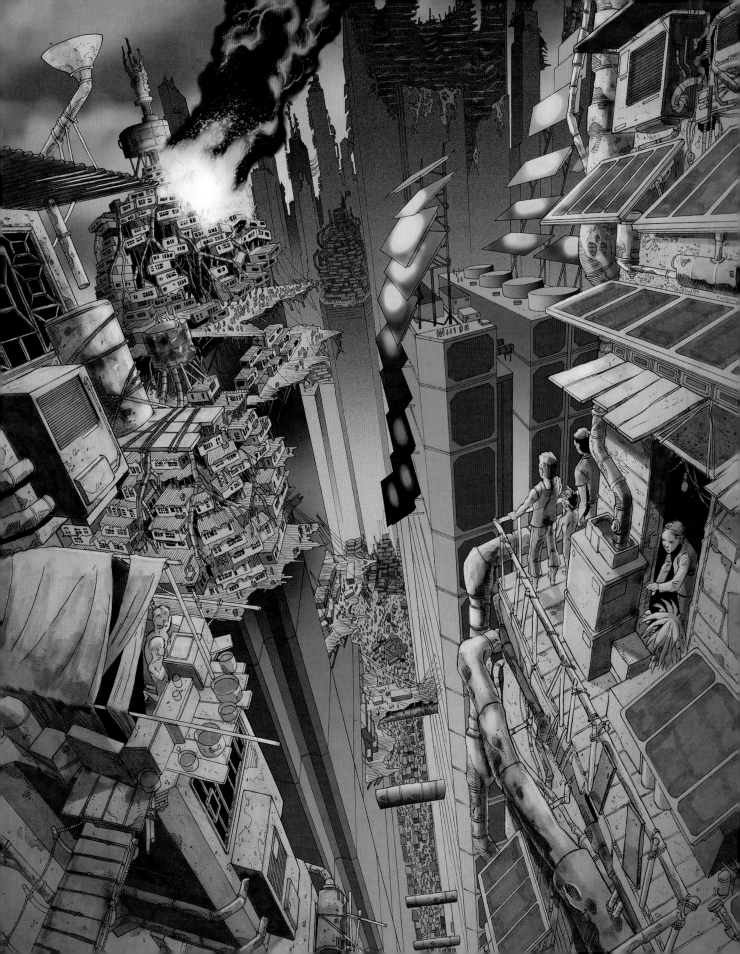

INTRODUCTION
WHAT IS SCIENCE FICTION?

It's fiction that starts with some scientifically established fact, and that extrapolates from that fact to some state of affairs that might result from it in the future or in some alternative present. The purpose of sci-fi is—to entertain, of course. But almost always it has a second goal: to get us to reflect on the world as it is, and to warn us about where we might be heading. Because it's rooted in science, sci-fi always deals essentially with *explanations,* unlike its cousins horror and fantasy. If it's a horror story, it's enough *that* the monster is attacking. If it's a science fiction story, we have to know *what* the monster is, *where* it comes from, and *why* it's attacking.

Sci-fi stories are almost always set in the future, and depending on whom you ask, that future is going to be very good or very bad. Visions of the future tend to fall somewhere along a visual/conceptual spectrum, ranging from the extremely hopeful at one end to the extremely dire at the other. *Star Trek* presents us with a twenty-third century in which poverty, warfare, and ignorance have all been virtually eradicated, and in which mankind is united in the exploration and peaceful colonization of the furthest regions of our galaxy. The *Matrix* trilogy presents us with a twenty-second century in which most of humanity is enslaved by machines that rule Earth's ravaged surface, and in which the few not so enslaved endure an agonized existence deep underground. In all of pop culture—in literature, film, and comics—this pattern is evident, with visions of tomorrow falling somewhere on this scale of optimism versus pessimism. All of this reflects a deep psychological need that is universal

OPPOSITE: *The Population Dystopia* (see page 179). An image of what we might face if human numbers are not somehow controlled.

and perennial. Conjuring visions of the future—both the beautifully hopeful and the appallingly horrifying—is one of the ways in which we unify our understanding of the present, and come either to embrace it or demand that it be changed. And our individual temperaments are our biggest (and always unspoken) premises in how we envision the future.

This book is about drawing the future (and sometimes the alternate past) on paper—both the utopian and dystopian varieties. I've organized it around the utopia/dystopia theme because of its central and perennial nature, and because it gives us a rough-and-ready metric for assessing what kind of sci-fi we're talking about. The main challenge for me in making this book was coming up with over 30 sci-fi images/test cases, each of which is significantly different from all the others, and each of which clearly exemplifies some way in which the utopian and dystopian impulses manifest themselves in our imaginings of the future. The book is peppered throughout with images from sci-fi films, as further examples of these imaginings.

After a brief chapter on some drawing basics, we'll get down to the nuts and bolts of sci-fi drawing in particular. We'll move from small vistas to large, starting with human beings, moving on to robots and aliens, then land and space vehicles, and culminating with vast cityscapes.

The general process I've adopted has been tailored to address a number of basic skills: brainstorming/doing rough sketches, converting roughs into finished pencil drawings, converting pencil drawings into finished ink drawings, and coloring the inked drawings. A few of the pieces have been left in glorious black and white, and in some cases I found it useful to do preliminary color studies with markers before doing a final digital color version. I chose to do all the final coloring in Photoshop to appeal to those interested in digital painting. All of the pieces in this book were made according to the procedure outlined above. With almost all of them I made a hi-res (600 dpi) scan of the final line art (saved as a jpeg), opened it in Photoshop, and then saved it as a Photoshop file, which you will see throughout the 33 demos.

The process you adopt will be particular to you, the result of experimentation and honing in on whatever makes you comfortable and helps to spark your creativity. But

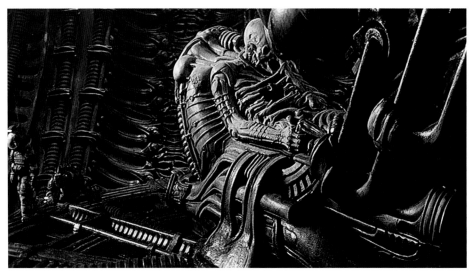

there are a number of considerations that just about any sci-fi artist is bound to agree with, and I want to start hammering them home right away. They are:

THE IMPORTANCE OF INFLUENCES

It helps to have a personal god or two in your development as an artist—an aesthetic "gravitational mass" around whom you orbit for a while as you develop (just be darn sure you leave orbit and take off on your own trajectory when you're ready). I've had many— graphic artists, comics artists, and film conceptual artists. The two that count the most for me are the American artist Syd Mead, well known for his designs for *Blade Runner*, *Tron*, *Star Trek: The Motion Picture*, and many others, and the Swiss surrealist painter H. R. Giger, perhaps best known as the designer of the creature from the film *Alien*. Talk about utopian versus dystopian—these two are the Apollo and Dionysus of sci-fi art. Where Mead is all logic, clean lines, and rational, inviting vistas, Giger is nightmarish creatures and hellscapes dragged from the darkest caves of the subconscious. Both of these great men have exercised a massive, lifelong influence on my own art. Studying the work of role models like these will simultaneously fire and discipline your imagination.

ABOVE LEFT: A Spinner, or flying police car, from *Blade Runner* (Warner Brothers, 1982). Designed by Syd Mead. A beautiful and convincing blend of form and function.

ABOVE RIGHT: The so-called space jockey from *Alien* (20th Century Fox, 1979). Designed and sculpted by H. R. Giger. One of the greatest biomechanical nightmares ever realized on celluloid.

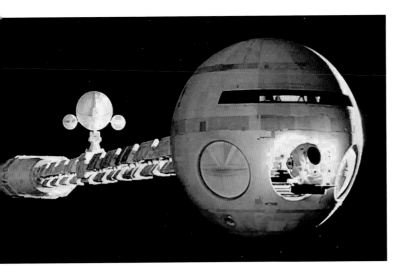

THE IMPORTANCE OF AUTHENTICITY

You are the god of whatever sci-fi world you create, and as such you have to know it inside and out; you are its sole authority. If your viewers can see that you don't care enough about what you're drawing to make it look authentic, they won't care either. Anatomy has to look accurate, technical stuff has to look functional, settings have to look lived-in, aliens have to look suited to some actual environment. Using visual references can double the authenticity of your artwork right off the bat—looking at photos of engines and other machines when you're drawing high-tech stuff, for instance. This has never been easier now that we have Google, and there's just no excuse not to. Again, studying the work of other artists can (oddly enough) greatly amplify your own authenticity. My goal as an artist is to avoid that "made up" look as if it were the plague—I want everything I draw to look as if I *saw* it, not as if I imagined it. But note that authenticity does *not* entail verisimilitude or strict realism. Sci-fi can be authentic but still highly stylized.

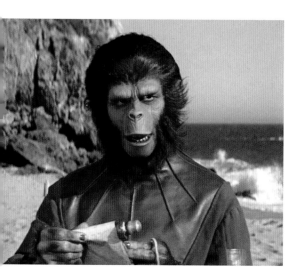

THE IMPORTANCE OF VISUAL TOUCHSTONES

As you're drawing, you have to keep asking yourself a number of questions. Some of them are:

Is it *authentic*? (See page 12.)

Is it *honest*? Is it an expression of your own vision/aesthetic, or are you copying someone else? If the latter, stop it!

Is it *eye-catching*? Is the subject matter compelling, and if so, is your eye drawn through the picture by the placement of focal points and highlights? If you're bored, stop—your viewer will be bored, too.

Is it *clear*? A lot of detail is just fine—but not if it has taken over entirely. The forest should be the first thing you see, not the trees.

Does it *read* quickly and easily? That is, can you tell more or less at a glance what you're looking at (a spaceship? A human? An alien? A city?)? If not, it could mean you need to tighten things up, change the composition, or start over.

Is it *awesome*? Part of what I mean by this is: every vehicle I draw—be it spaceship or landship—is something my twelve-year-old self would have loved to be in. Would your twelve-year-old self dig whatever it is you're drawing?

ABOVE LEFT: "Beware the beast Man," from *Planet of the Apes* (20th Century Fox, 1968). One of the all-time great thought-provoking masterpieces.

ABOVE RIGHT: The liquefied dead being fed to the living, from *The Matrix* (Warner Brothers, 1999). One of sci-fi's great dystopias.

THE IMPORTANCE OF THOUGHT

As I said, sci-fi has an element of conceptualization that other forms of speculative fiction don't require. It is rooted in science, and usually has a didactic aim: to spur us to reflect on our present situation. Doing sci-fi art should never *just* be an exercise in drawing cool pictures. It should be coming from a place of imaginative engagement with how you think the future should be, or how you're worried it will become, or how you hope it will turn out. Every one of the pieces in this book has a story connected with it. Often, only by thinking long and hard about that story was I able to figure out how to draw the piece. Each of the final works is accompanied by a few sentences about that story, and by a date to indicate when in time I see it unfolding. I hope this will serve as a constant reminder of the intimate connection between good sci-fi art and thought-provoking narrative.

RIGHT: The Time Machine (see page 135). One of the most perennially thought-provoking ideas in all of sci-fi.

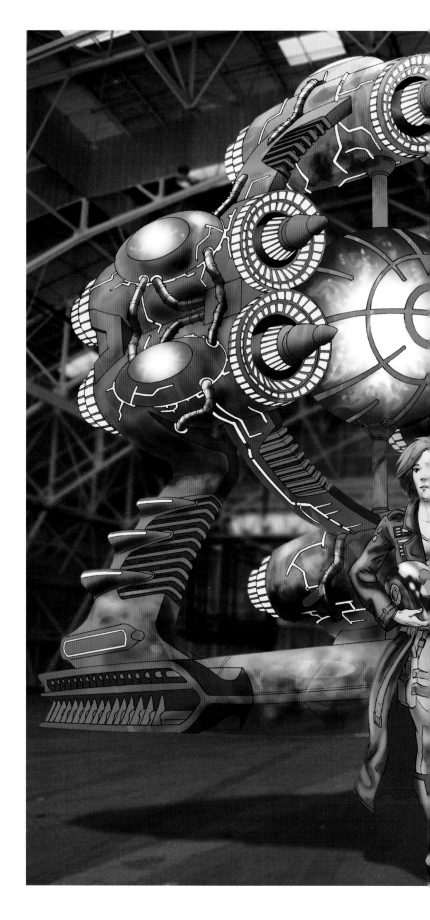

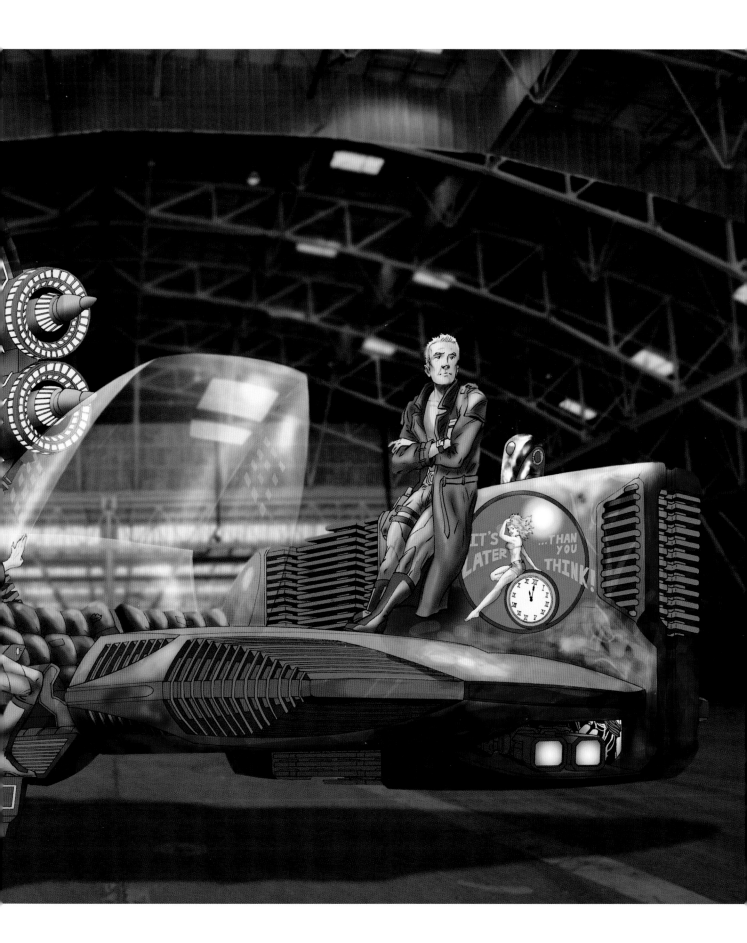

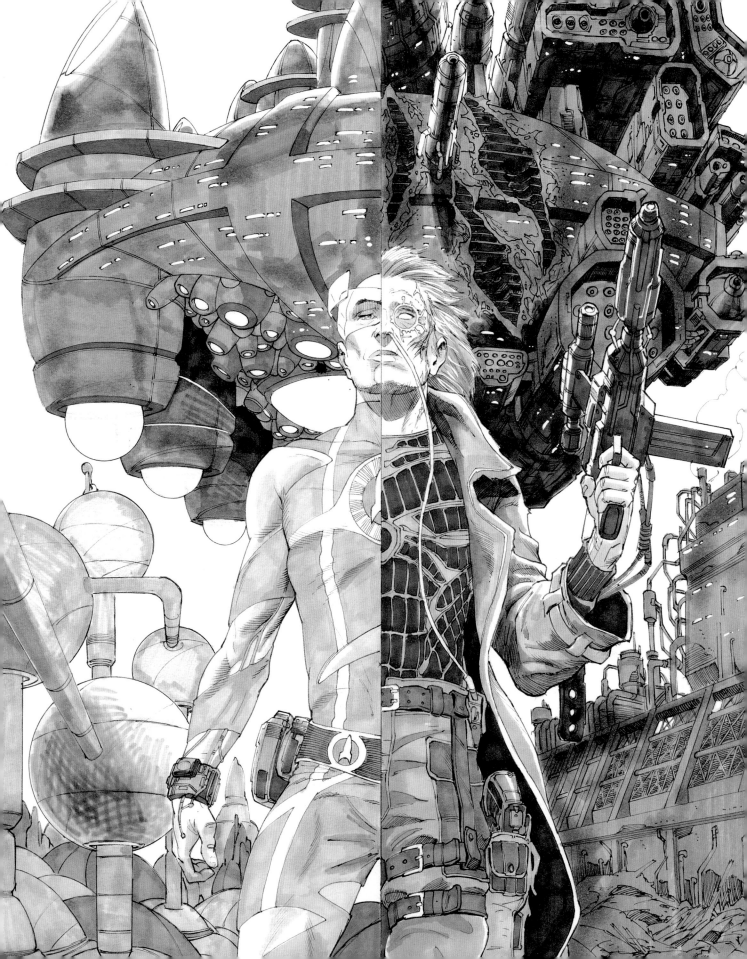

SOME DRAWING BASICS

Drawing—making pictorial representations with lines and other marks—is a fundamental constant of human nature. Virtually every human child draws instinctively, if only they have the tools. Drawing is also one of the great and profound pleasures of life. This chapter is for young people who love to draw and want to hone their skills, or for those who are returning to drawing after some time away and who want a brief refresher course. I'll touch on what I take to be the absolute essentials: drawing materials, the basics of perspective, the human face, the human body, light and shadow, rendering techniques, and composition.

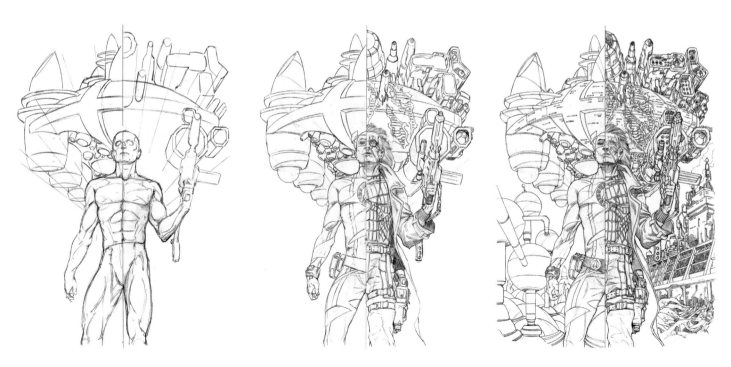

OPPOSITE: An early gray-tone marker study of the cover image (which includes a weapon that was later removed).

ABOVE: Three stages of the image as it approaches completion.

materials

The specific materials you end up using will be the result of personal experimentation and trial and error. The ones I recommend here are those that I used in producing the images in this book, and are my preferences based on many years of experience.

I use two-ply Bristol board for final drawings; most brands are pretty good. It comes in smooth or rough finish; whichever you choose is a matter of taste. Cheaper drawing paper or bond paper is good for quick sketches.

I generally use mechanical pencils because I hate sharpening. I use .3 and .5 HB leads. Plastic erasers like those shown here clear away pencil marks cleanly.

I use felt-tip pens sometimes, but for finished pieces I use technical pens (one well-known brand is Rapidograph), which are more expensive. They're a pain—they clog, you have to refill and clean them, and they leak on airplanes. But you simply cannot get the same quality of line with any felt-tip pen, period.

RIGHT: Some of the markers I use for sketching, as well as for tone and color studies. These brands—Prismacolor, Letraset, and Copic—are excellent.

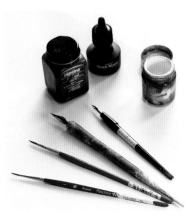

I use dip pens and brushes like these with india ink when I'm drawing organic things, like people.

Some of the rulers and templates I rely on for inking straight lines, circles, and ovals. The one on the right is a french curve—indispensable for drawing and inking curving lines.

White ink, which is indispensable for correcting mistakes and neatening up final images. I've done drawings that look like bas-reliefs from all the white and black ink piled on one another.

Masking film, cutting board, penknife. These are essential for doing spatter effects on paper, as I'll demonstrate in later chapters.

My drawing board and light box. A light box makes life easier when, for example, you want to use a quick sketch as the basis for a more finished drawing on a piece of higher-quality paper. It's great for tracing.

My Wacom Cintiq tablet for using Photoshop (optional, of course!). The tablet comes with a pressure-sensitive pen that allows you to draw, paint, and otherwise manipulate images directly on its screen. Photoshop is a vast and powerful bit of software; like most digital artists I use only a few of the tools it has to offer (I rely mostly on the selection tool, the brush tool, the gradient tool, the fill option, the dodge/burn tool, and the blur/smudge tool). With a few well-chosen You-Tube tutorials, you can be comfy with Photoshop in hours. Stick with it and you'll be pretty good in a week. Manga Studio EX5 is also excellent, especially if you want to do your drawing on a tablet.

Perspective

Perspective is a system of conventions artists use for making realistic and convincing representations of objects in space; it creates the illusion of depth and distance. Perspective works—thanks to the (more or less) Euclidean nature of space and the (more or less) straight-line behavior of light rays. If you can master just a few basic perspective concepts, you'll be on the road to making your drawings of things in space look believable.

A few simple definitions are needed here. A *horizon line* is a line with one or more vanishing points. A *vanishing point* is a point, often but not always on a horizon line, toward which perspective lines (straight lines that guide your drawing of objects) converge. Drawings can have multiple vanishing points, depending on your viewpoint within the drawing and the degree of realism you're going for. All of this will become clear in what follows.

VANISHING POINT HORIZON LINE

ONE-POINT PERSPECTIVE

A block drawn in one-point perspective. The perspective lines converge toward a *single vanishing point* on the *horizon line.*

A piece from this book in one-point perspective. The horizon line is in blue, perspective lines are red.

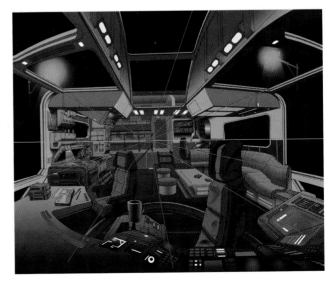

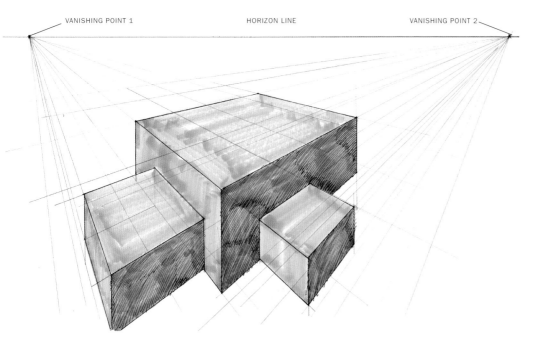

VANISHING POINT 1 HORIZON LINE VANISHING POINT 2

TWO-POINT PERSPECTIVE

LEFT: A shape in two-point perspective; the shape converges toward two vanishing points.

BELOW: A piece from this book; the foreground ship is in two-point perspective. Of course there's no real horizon in space—the horizon line (here in blue) is assigned arbitrarily by you. The red lines recede to vanishing point 1, and the yellow lines recede to vanishing point 2, which is well out of frame.

THREE-POINT PERSPECTIVE

Here, multiple shapes are constrained by *three* vanishing points. Vanishing point 3 is chosen arbitrarily, and points 1 and 2 are anchored to the horizon line.

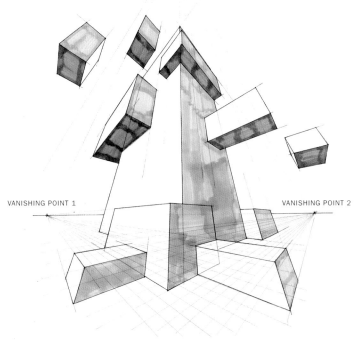

VANISHING POINT 3

VANISHING POINT 1

VANISHING POINT 2

FOUR-POINT PERSPECTIVE

This piece has *four* vanishing points. The purple lines converge to a vanishing point deep underground; the green and yellow lines recede to points on the horizon line but out of frame. An even bigger drawing could have a fifth vanishing point in the sky; this would produce something very like a fish-eye lens effect.

THE BODY IN PERSPECTIVE

The human body is a (semi-) rigid object and so must be drawn in perspective. Here we see a body being blocked out in accordance with two vanishing points.

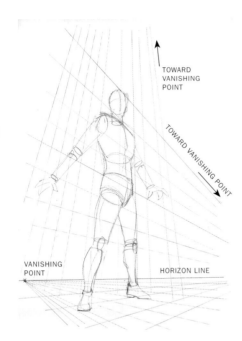

TOWARD VANISHING POINT

TOWARD VANISHING POINT

VANISHING POINT

HORIZON LINE

The same drawing finished with pencil and a quick Photoshop treatment. As you learn to draw bodies correctly, you'll find yourself *automatically* putting them in perspective.

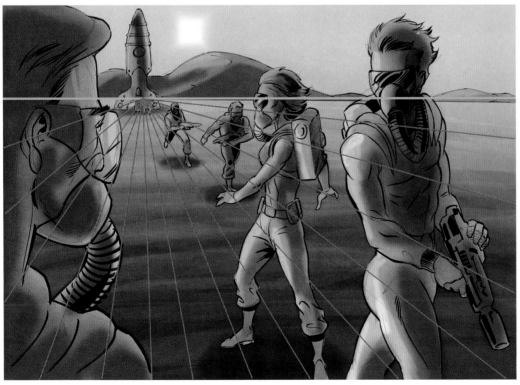

A quickie of bodies converging into the distance. Our viewpoint is about at head level; notice that *all* the heads are (about) at this level.

MULTIPLE HORIZON LINES

Sometimes a single piece will have *two* horizon lines! In this piece, the city and characters are governed by one horizon line, and the spaceship by another. This creates the impression that the ship is tilted downward, toward us.

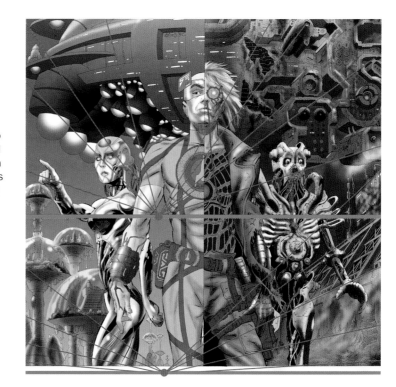

BELOW: Our viewpoint is about at knee level in this image, as the two red patches indicate. Notice that *all* the knees in the image are at this level.

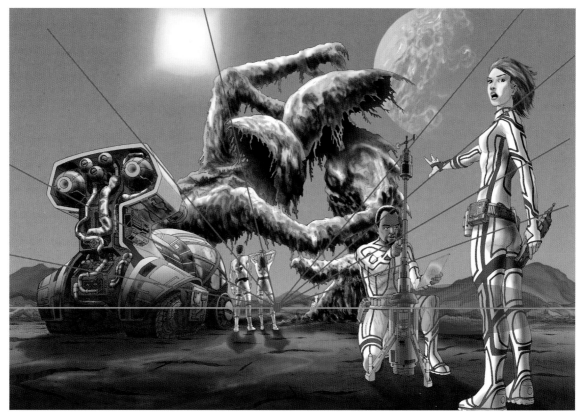

THE HUMAN HEAD/FACE

The face has been the object of greatest concern in the history of visual art, so it's important to try to get it right. Luckily, we can approach it scientifically and lay down some basic rules. For example, the head is shaped like an upside-down egg, and the eye line falls exactly halfway down. These rules are almost always honored in the breach, not the observance—they are just guidelines. But you have to master them if you want to be able to portray people convincingly.

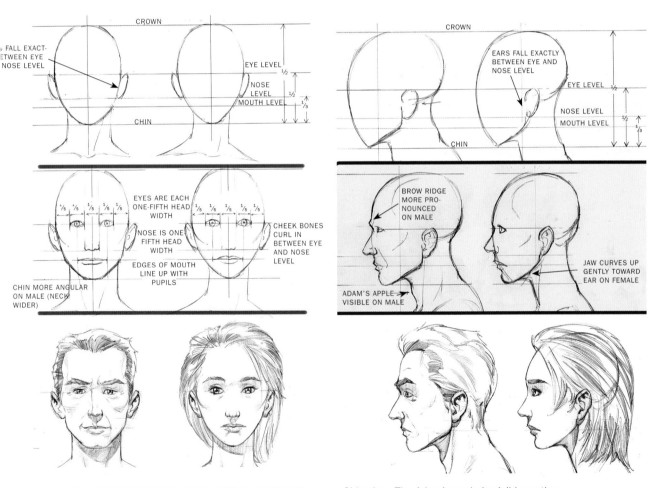

Developing the human head and face, male and female, front view. These are guidelines only; once you memorize them you'll start to notice all the interesting ways in which people actually deviate from them. Some key points: the eye line is halfway down, the head is five eyes wide, the ears fall exactly between the eye and nose line. Everything on the male is more angular than on the female.

Side view. The Adam's apple is visible on the male but not the female. The female jawline curves up more gently toward the ear. The brow ridge is more prominent on the male.

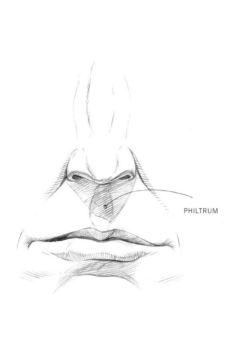

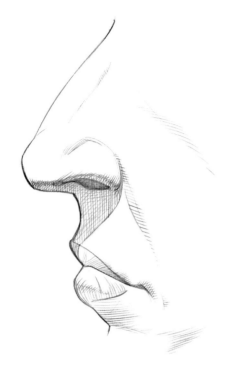

PHILTRUM

The nose, philtrum, and mouth. Note the shadow cast beneath the nose and upper lip, and by the lower lip.

Nose and mouth, side view.

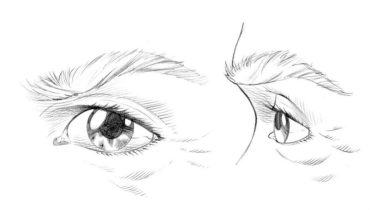

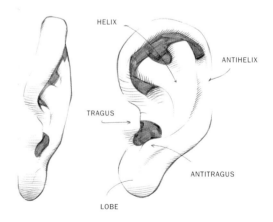

HELIX

ANTIHELIX

TRAGUS

ANTITRAGUS

LOBE

The eye, front and side. Note the shadows cast beneath the upper lid, and reflected light in the eyeball.

The ear, front and side. Everyone has the letter "Y" in his/her ear.

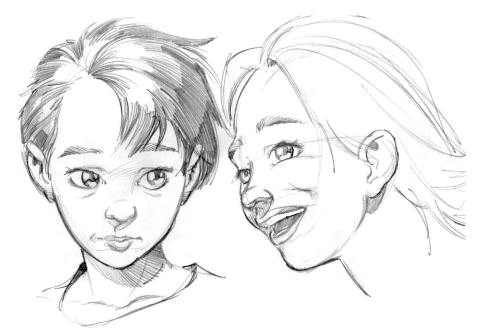

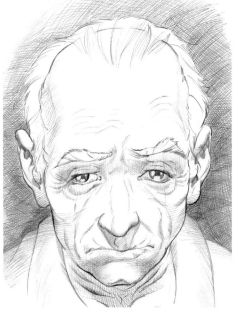

LEFT: With children, you basically stick to the same rules, except the eyes and ears are bigger, the nose and mouth smaller, and everything is softer and more rounded than in adult faces.

RIGHT: A face on which time has done its dirty work. The ears and nose are bigger, the eyes smaller. Gravity is making everything sag.

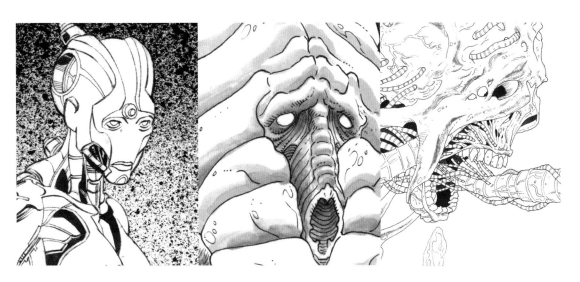

LEFT: Alien and robot faces are usually deviations from the human standard. But they have recognizably human features.

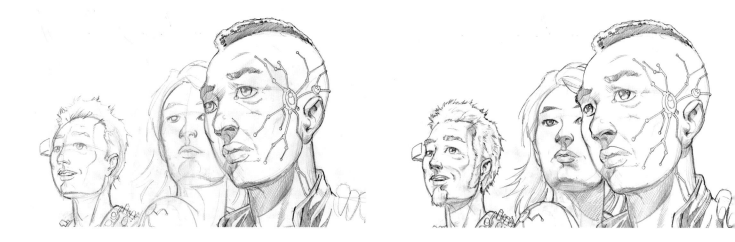

ABOVE LEFT: A few random faces in three-quarter profile, seen from slightly below. Here in step one, note the visible construction lines on all the faces.

ABOVE RIGHT: Step two, finishing the pencils.

RIGHT: Step three, the drawing after a quick Photoshop treatment.

THE HUMAN BODY

The human body is the hardest thing you'll ever draw, and the most rewarding. The best way to learn how is by doing it from live models in drawing classes, but it is essential to commit to memory some basic facts about proportions, muscle groups, the big differences between male and female bodies, and foreshortening. Those are the things I'll concentrate on here. Remember—there are no shortcuts, and no substitutes for studying and sketching living people and studying the work of other artists.

THE MALE BODY

The male from the front, showing overall proportions and some major muscle groups. This figure is about 7.5 heads tall, which is normal for a man of average height. Note that the elbows are level with the navel, and the wrist is level with the crotch. There is exactly one head height between navel and crotch. On the male, the shoulders are somewhat wider than the hips. Beneath the nipples is the abdomen, a complicated area. The ribs are covered with a muscle group called the *serratus anterior*, and these mesh with the muscles below them. This is one of those places where drawing live models really helps with understanding.

CLAVICLE
TRAPEZIUS
DELTOID
NOTE THAT SHOULDERS ARE WIDER THAN HIPS
BICEP
NAVEL
ELBOWS ARE LEVEL WITH NAVEL
FORWARD CREST OF PELVIS BONE
WRISTS ARE LEVEL WITH CROTCH
QUADRICEP (THIGH MUSCLE)
NOTE THAT INNER ANKLE IS HIGHER THAN OUTER ANKLE

NOTE THE "S-CURVE" OF THE BACK

TRICEP

DELTOID

LATISSIMUS DORSI (THE "LATS")

EXTERNUS OBLIQUE

NAVEL

SARTORIUS (BODY'S LONGEST MUSCLE)

HIP BONE (LEVEL WITH CROTCH AND WRIST)

GASTROCNEMIUS (THE CALF)

HAMSTRING

The male from the side. Note that the hip bone is level with the crotch and wrist, and the general S-shaped curve of the spine. The figure's left triceps (at the back of the upper arm) and right calf muscle are bunched up, or *flexed*—that is, they are working. In general, muscles work the part of the body that is *next farthest out*—e.g., the biceps and triceps of the arm work the forearm, which is farther out. The figure's calf is flexed because it's working that bent foot.

THE FEMALE BODY

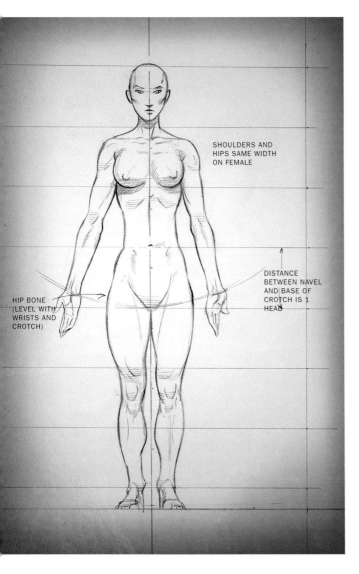

SHOULDERS AND
HIPS SAME WIDTH
ON FEMALE

DISTANCE
BETWEEN NAVEL
AND BASE OF
CROTCH IS 1
HEAD

HIP BONE
(LEVEL WITH
WRISTS AND
CROTCH)

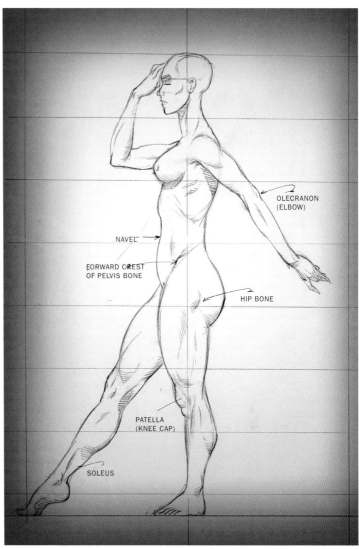

OLECRANON
(ELBOW)

NAVEL

FORWARD CREST
OF PELVIS BONE

HIP BONE

PATELLA
(KNEE CAP)

SOLEUS

The female from the front. The basic proportions are the same as for the male. The shoulders and hips are about the same width. Muscles tend to be softer, indicated more subtly.

The female, side view. Again, note the S-curve of the spine. The right biceps is flexed (it's working that lifted forearm). The quadriceps (thigh muscle group) and calf of the right leg are also flexed and bulging. The forward crest of the pelvis bone is *subcutaneous*—that is, it attaches directly to the skin. Other key places in the body where the bone is subcutaneous: the elbow, hip bone, breast bone, kneecap, and the skull and cheekbones.

BUILDING THE FIGURE

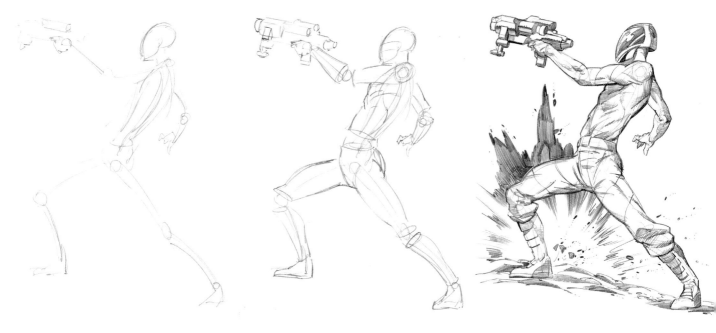

ABOVE, LEFT TO RIGHT: Building up a male figure. Step one: This is all about putting a *gesture* on paper, a basic sweep of action. My subject is little more than a stick figure here. Step two: chunking out the figure, but still treating him as simple forms (balls and cylinders). Step three: adding details and shadows. Varying the line weights adds rhythm and dynamism. Note that you can still see the construction lines.

RIGHT: The same process with another figure.

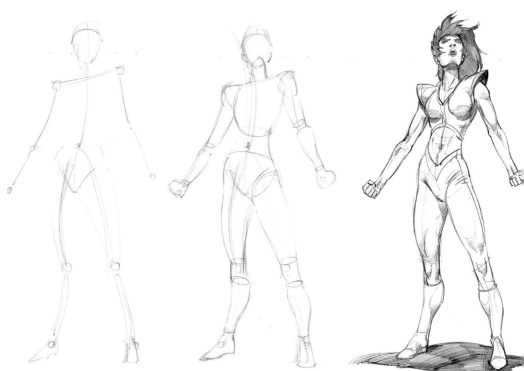

CLOTHING

Drawing clothed figures is another ball of wax. Clothes bunch, sag, wrinkle, and crease where you'd expect: at the body's joints and hard parts (the armpits, crotch, elbows, and knees). Studying and copying photos (of fashion models, e.g.) is great practice for this.

FORESHORTENING

LEFT: A foreshortened arm/hand. Note that the hand is *bigger* than it otherwise would be, and the line work around it and the arm are heavier. These visual "hints" help with foreshortening.

BOTTOM LEFT: An object is *fore-shortened* when it is tilted toward our viewpoint, making it appear shorter on the axis of tilt, as with this cylinder and ball.

BOTTOM RIGHT: A figure foreshort-ened from above. The head-to-feet size relationship is exaggerated. Putting the figure in accurate per-spective and adding a rigid object (here, the control panel) in the same perspective are more "hints" that foreshortening is being used.

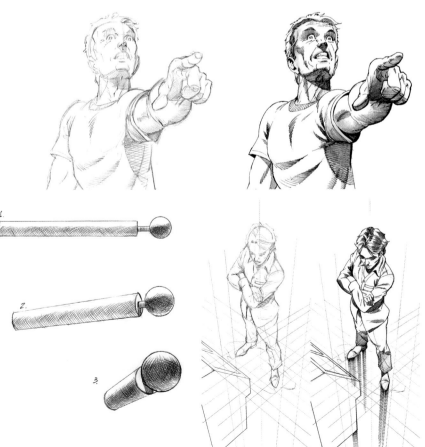

SILHOUETTE

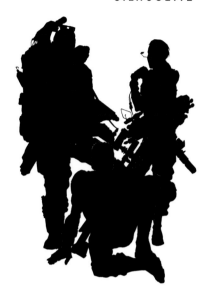

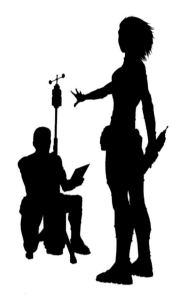
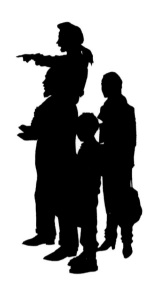

Clarity is crucial—ideally you should be able to take in at a glance what a drawing is of or about. Whether or not a figure is recognizable as such *in silhouette* is a good test of clarity. These three silhouettes are from pieces in this book. Get used to "knocking figures out" in silhouette in your mind as you're drawing them—if they aren't quickly recognizable as figures, it could mean they need reworking.

MIRROR IMAGE

Get used to holding your pieces up to a mirror; they should work equally well in reverse. If they look wonky when reversed (and mine often do), that means there is a problem, usually with proportions or anatomy. Looking at your work in a mirror is a very easy test for drawing quality.

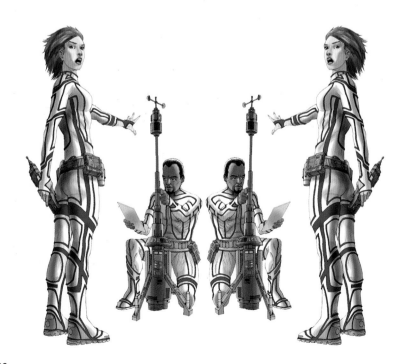

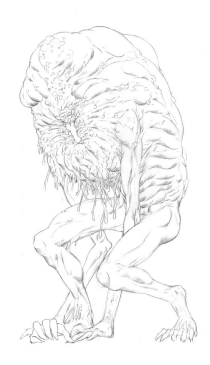

AN INHUMAN BODY

Aliens and monsters, no matter how strange, are almost always rooted in human physiognomy. Part of what makes them fascinating/horrible is precisely that we see part of ourselves in them, only distorted. This guy has remarkably human arms and legs. Shown above is my initial quick sketch followed by a later step with the nasty details fleshed out. At right is the result after a quick (about two-hour) Photoshop treatment.

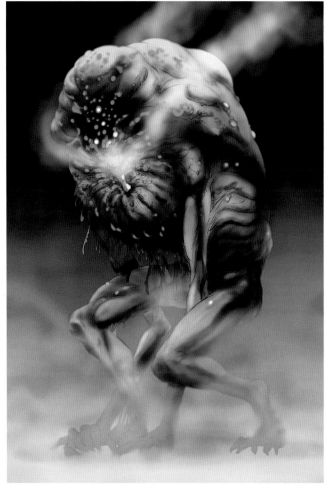

Light, Shadow, and Rendering

There's a very real sense in which all we ever draw (or paint) is light itself. A huge part of learning to draw is learning to observe and reproduce from memory the way light falls on objects, particularly on noodly objects like the human body. The central distinction I want to make clear is that between *direct* light (light hitting an object directly from a light source like the sun) and *reflected* light (weaker light reflected from other objects, usually hitting an object from below). *Rendering* means the various ways in which you can represent light, shadow, and surface textures using such techniques as cross-hatching, spatter, wash, stippling, and so on.

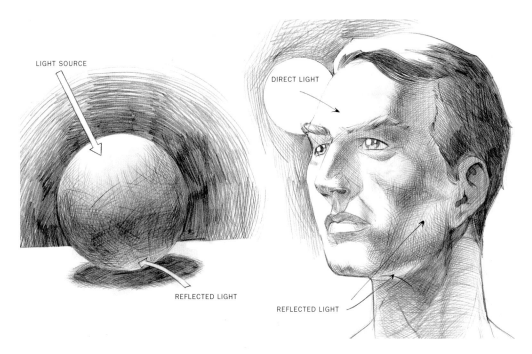

ABOVE: A ball and face, lighted from above, rendered with cross-hatching. Adding subtle reflected light on the downward planes (beneath the jaw and cheekbones, e.g.) helps indicate shape and mass, and adds realism. Note also that the surfaces closest to the direct light source (the forehead and nose) are indicated with very light outlines; this is another clue as to where the light source is. Surfaces facing away from the light source get a heavier outline.

OPPOSITE: A variety of lighting and rendering techniques. 1. Light from above; basic cross-hatching with dip pen and black and white ink. 2. Light from below; pointillism, technical pen. 3. Light from the side; a high-contrast, graphic style, done with dip pen and brush and india ink. 4. Strong backlight; white ink for spatter burst (I used masking film to cover the face and a toothbrush to apply the spatter). 5. Light from above; ink wash (I used a brush to add layers of heavily diluted india ink). 6. Light from above; charcoal.

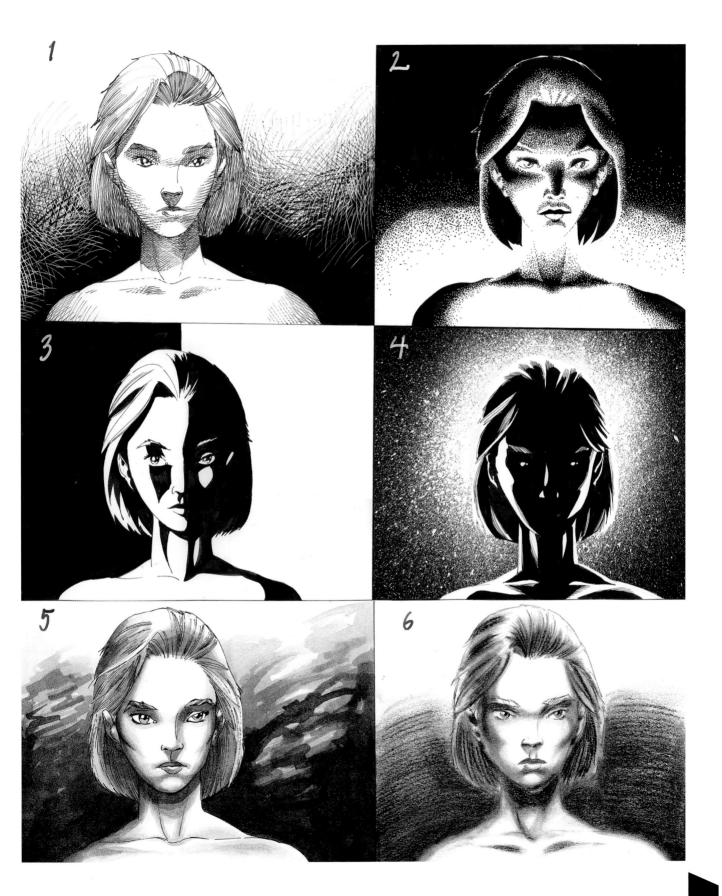

A pen-and-ink drawing with numerous rendering techniques. I used white ink on black to indicate brickwork and shingles on the shadowed side of the house, and white cross-hatching over black ink on the sign. Note the little stipples used to indicate stone on the side of the sign, and the almost abstract, wavering lines used for the sky. There are no rules here; you can invent any technique you want.

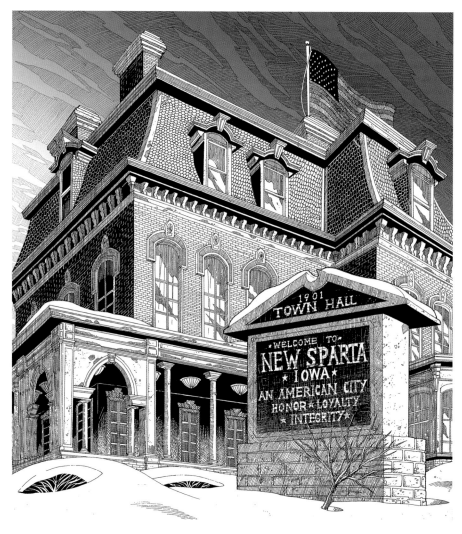

Detail from a piece in this book—another quasi-abstract treatment of the sky, plus white spatter for the sun. I used black-and-white layered cross-hatching on the robot.

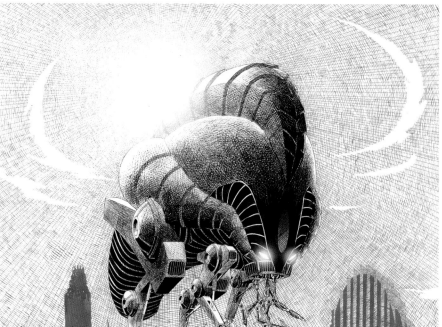

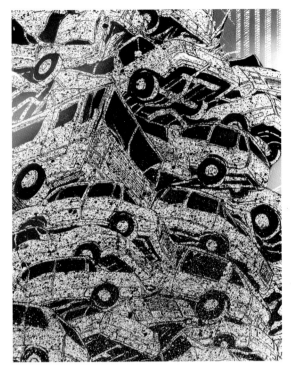

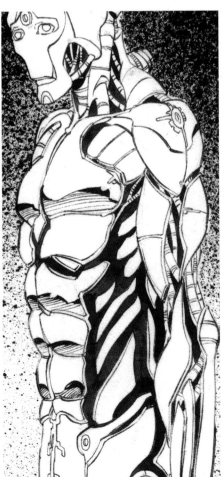

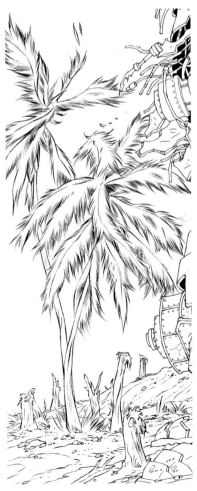

ABOVE LEFT: I used black spatter in rendering the old cars.

ABOVE RIGHT: Here I used dots and ticks to depict stone/brick textures.

LEFT: To render chrome/metal I used curving lines and small white highlights.

RIGHT: I used a dip pen and photo references to capture these swaying palms.

I executed this piece (shown in full elsewhere in the book) with multiple rendering techniques, including black and white layered cross-hatching and white spatter for the explosions. The image is very strongly backlit.

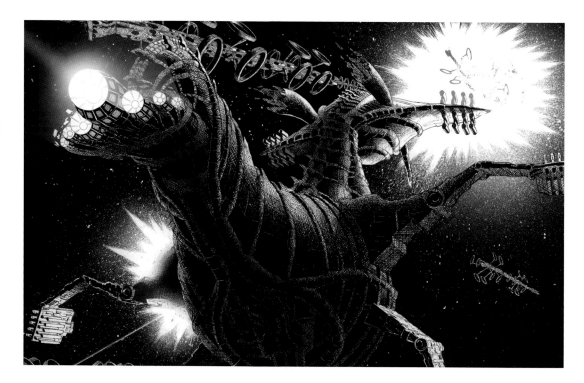

Another piece from this book; this one is very strongly sidelit.

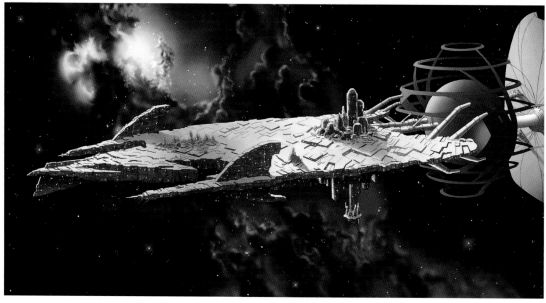

COMPOSITION

Composition refers to the way in which elements are arranged within a picture to (ideally) produce an aesthetically pleasing whole. When you're thinking about composition, you figuratively swoop out from the trees in order to observe the forest as a single thing. Generally speaking, a well-composed drawing is one in which the eye is drawn toward the center of interest (or a focal point) by the careful use of lines, light and shade, cool and warm colors, positive and negative space, the representation of spatial depth, and the delegation of size to objects based on their importance. A nicely composed piece is *balanced*, but this rarely means symmetrical, or having its focal point dead center. Most good drawings are balanced, but in an *unstable* way. Some examples will help you see this—in what follows I've taken some of the images in this book and added tinted overlays to emphasize the compositional effects I was going for.

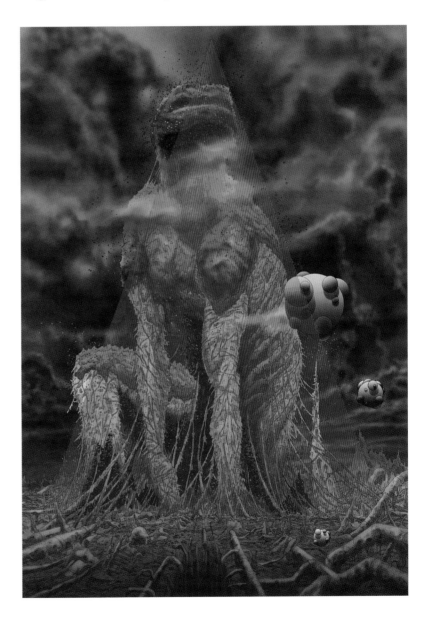

I gave this image a very strong triangular/pyramidal composition, which tends to be evocative of permanence, stability, and strength. The converging pipes at the bottom and the sweeping upward masses of the figure are meant to guide the eyes to its head. The floating orbs are meant to add depth and scale.

Twoness is a motif at work here; there's two of everything in this image (two aliens, two celestial bodies, two bits of tech, two groups of two people each). The aliens' heads are at the intersection of two massings of shapes, so the eye is led to them.

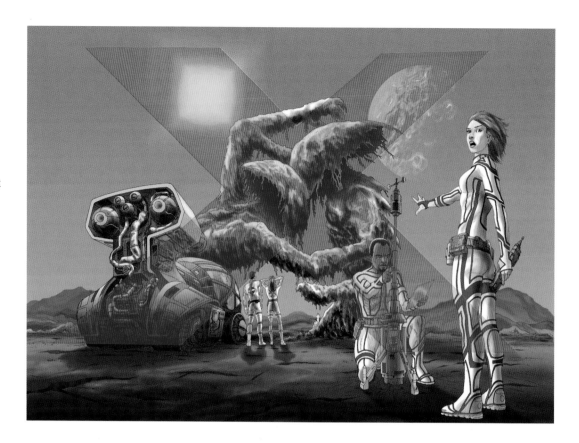

The family is the focus here; converging lines and masses, as well as highlights, tend to draw the eye to them.

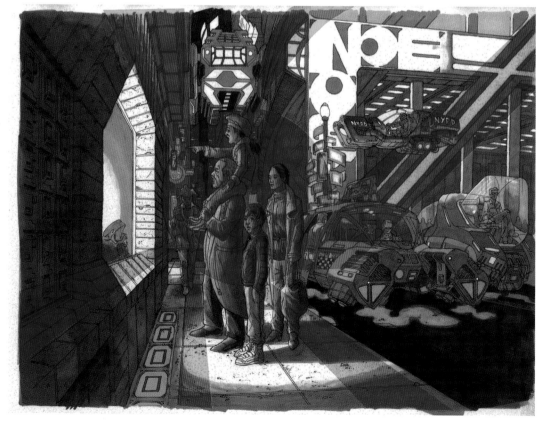

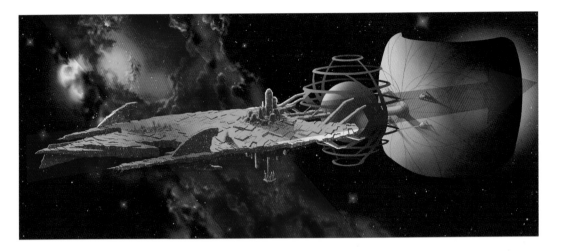

The eye (in the West at least) tends to read images as well as text from left to right. The eye naturally sweeps across the image here, taking it all in. The simple mass of the ship is nicely counterbalanced by the celestial mass in the background.

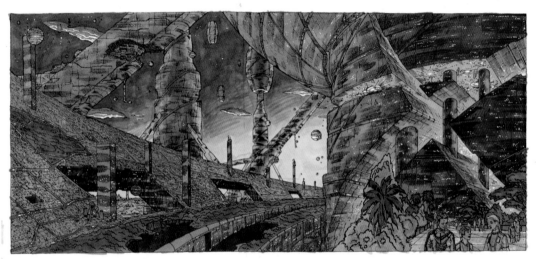

I wanted this to be a picture of harmony and balance, so I set up a blend of curving and straight masses and lines and horizontal and vertical masses. The cool-colored "negative" space of the sky counterbalances the warm-colored "positive" space of the foreground masses. These things—positive (projecting) and negative (receding) space, warm (tending toward red) and cool (tending toward blue) colors—also have to be thought through and chosen for their compositional effect.

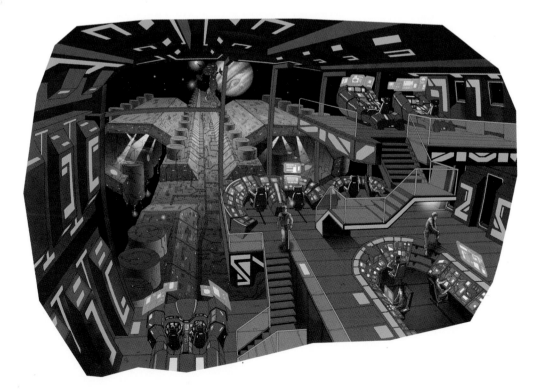

I wanted this composition to have a massive *forward momentum*; all those lines converging toward a single perspective point in the distance help with this. Everything converges toward Jupiter, another focal point of the image.

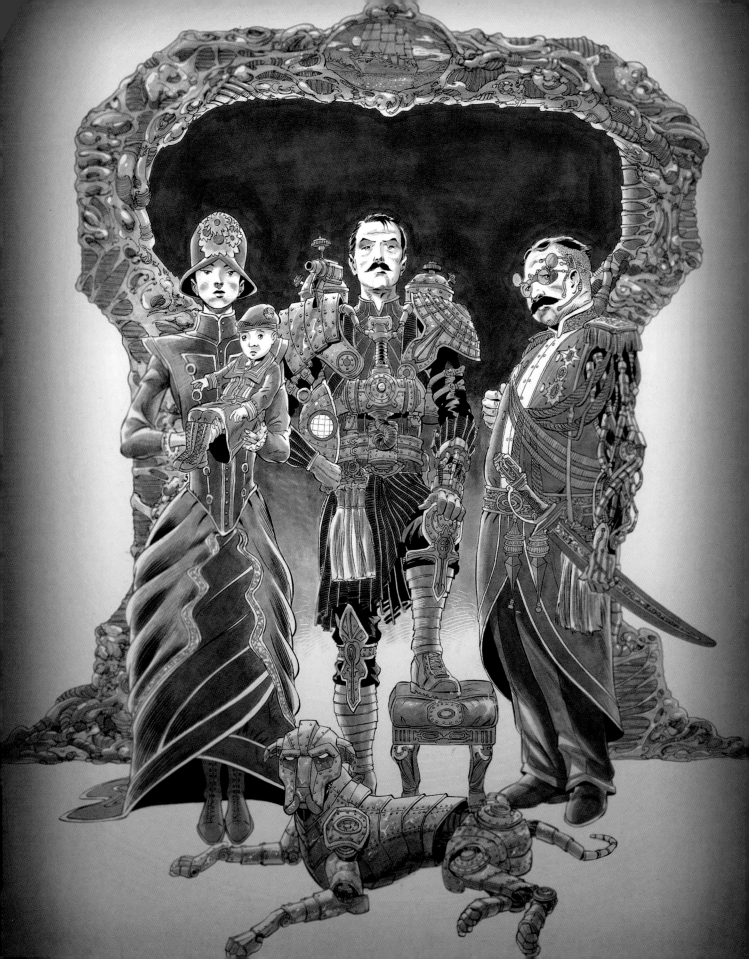

HUMANS

Human beings and the problems facing them always have been and always will be the single overriding preoccupation of all art, and science fiction is no exception. Will we live or die? Will evil ultimately triumph, or will good? Are we alone in the universe, or not—and if not, will we be bested by aliens, or live in harmony with them? Will we master the galaxy through science, or will our technology turn on and master us? Mankind is at the center of these questions, and the answers given by science fiction teeter between breathless optimism and spine-chilling pessimism. But without the image of man pushed to the limits of his resources, science fiction is a meaningless chess game. The character of Max gives the world of *The Road Warrior* what little hope it has, and *Star Trek* without Captain Kirk would be . . . hardly worth mentioning.

In this chapter I'll present you with (and guide you through the making of) my takes on some of sci-fi's recurring human standbys, utopian and dystopian alike.

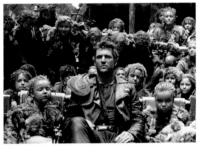

Mel Gibson as Max (with apocalypse survivors), from *Mad Max: Beyond Thunderdome* (Warner Brothers, 1985).

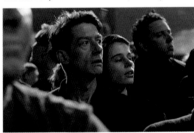

John Hurt (at left) as Winston Smith, from the soul-crushing dystopia of *1984* (Virgin Films, 1984).

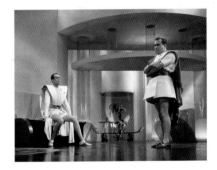

Futuristic citizens from *Things to Come* (London Film Productions/United Artists, 1936).

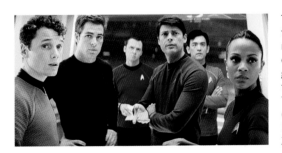

The crew of the *USS Enterprise*, from the film *Star Trek* (Paramount Pictures, 2009). A breath of fresh utopian air, given the generally dark contemporary sci-fi climate. Left to right: Anton Yelchin (Chekov), Chris Pine (Kirk), Simon Pegg (Scotty), Karl Urban (McCoy), John Cho (Sulu), Zoe Saldana (Uhura).

OPPOSITE: A steampunk family (see page 71). An image from an alternate reality—yet the attitudes, the humanity, are completely recognizable.

May 2144: The Criseis Lava Plateau, NGS-3394-B

Though it is currently lifeless, NGS (National Geographic Survey)-3394-B clearly wasn't always.

When first spotted from orbit, it was believed that the two grappling figures were approximately man-size. It was not until close inspection by this seismogeologic research team that the true stature of the bizarre tableau was revealed. Core samples indicate that the figures have been frozen in this iron-saturated basaltic lava for in excess of two million years.

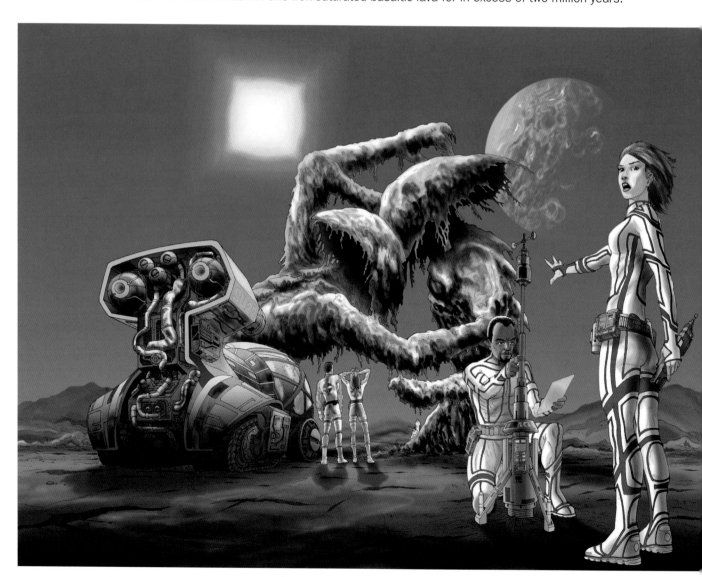

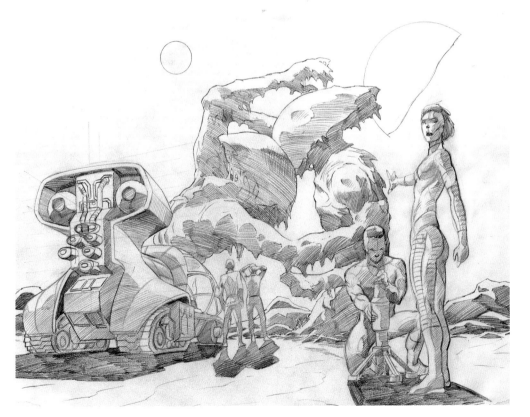

This piece started with the vehicle; at left above is the rough of it. I wanted something that looked durable/all-terrain (hence the treads), yet designed to afford maximal viewing (hence the big forward clear shell).

At right is a rough of the actual piece, working with perspective lines, on sketch paper.

Here is a more finished rough; I'm thinking about where the light is coming from and how it will fall.

I then make a hi-res (600 dpi) scan of the final line art (saved as a jpeg), open it in Photoshop, and then save it as a Photoshop file. Here I'm starting to color—just dropping in big color masses. The sun and planet effect were easily done with the gradient tool.

Working on the alien figures, using a variety of brushes and the dodge/burn tool.

Working on the vehicle. I spend a lot of time making and storing selections in Photoshop when doing things like this; it's necessary to isolate areas to get clean edges. I used the gradient tool to get the smooth light transitions on the vehicle's surface.

Almost done; here I'm working on the ground and background mountains. The "marching ants" (little dotted lines) indicate the area I've selected to work on. Note the layers palette at the right; it's vital to use separate layers so you can alter some elements without having to change everything else.

December 2502: Coenobites of the Order of Cyberascension

There is a long tradition of asceticism and self-mortification in mystic thought and millenarian creeds, and it was pushed to its logical conclusion by the Cyberascetics. The cult was formed in the wake of an apocalyptic vision by its founder, Medorah Strombom, of the Titan McHenry Orbital Mining Colony. She believed that holiness and serenity were achieved only to the extent that one "doffed" one's body, slowly exchanging one's organic mass for the sanctity of circuits and chips.

The orb floating at top is not a robot. It is this particular order's Archimandrite, or leader, whose still-living cerebral cortex resides in this shell. In time it too will be destroyed, the data patterns within it having been uploaded to the info-mass of the order's central computer; this alone the Cyberascetics regard as immortal and truly holy.

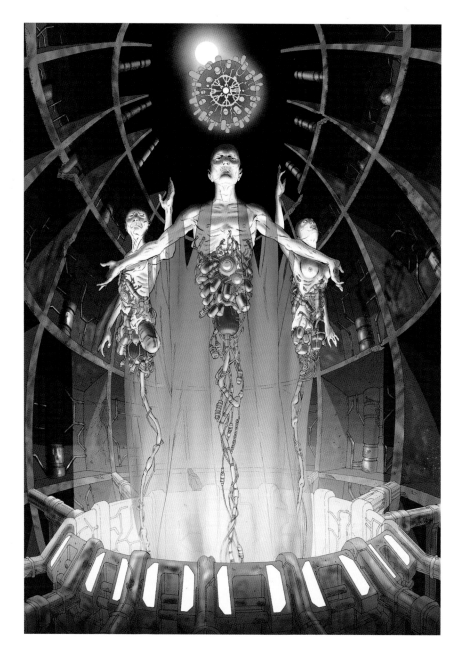

This is a horrific, dystopian image to us. But the people in this picture see themselves as being on the only true road to paradise. What seems extreme today may in time seem commonplace; sci-fi teaches that.

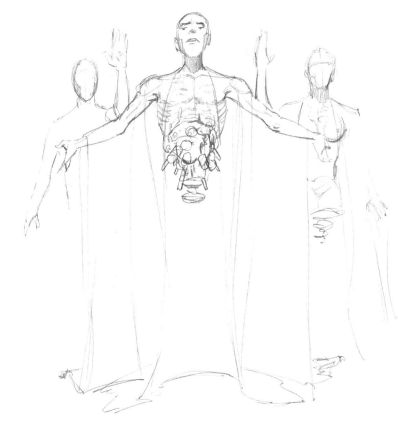

RIGHT: The initial rough of this piece. Just an idea, quickly scribbled down.

BELOW: The rough has promise, so I start some pencils on Bristol board. Left: roughing-in simple masses. Center: articulating the figures. Right: more details on the figures. Note that I decided at this point to have the figures emerging from a pit.

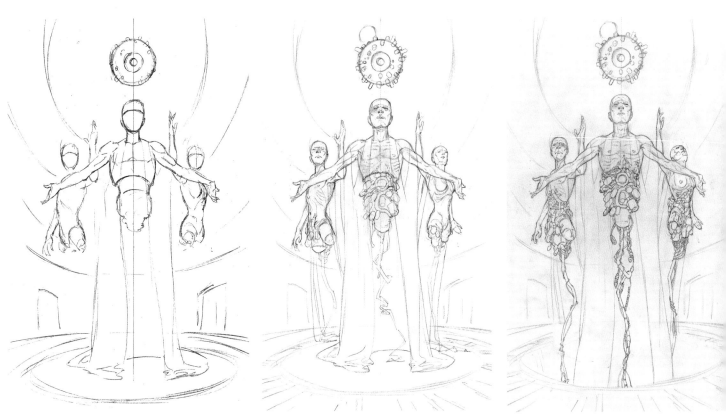

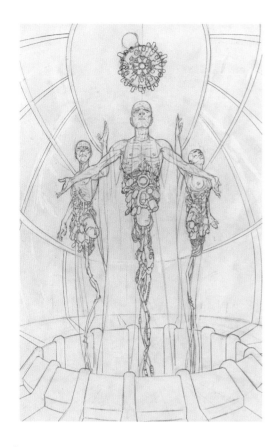

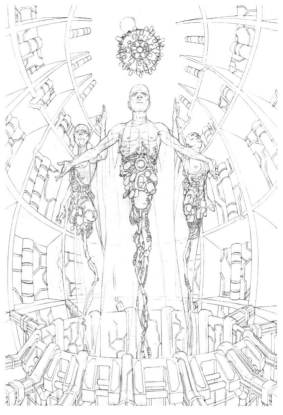

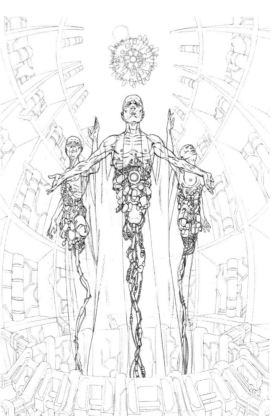

CLOCKWISE FROM TOP LEFT: Working out details of the orb overhead and the room. I'm not thinking overly much about it—just putting down interesting shapes.

The final pencils, ready for inking. The background elements were made to swoop upward, leading the eye to the sun and orb.

Starting to ink; the bodies were done with dip pen and india ink, the tech parts with Rapidographs.

The final inks. Note all the detail added to the background (stippling and cracks to indicate stone), not present in the final pencils.

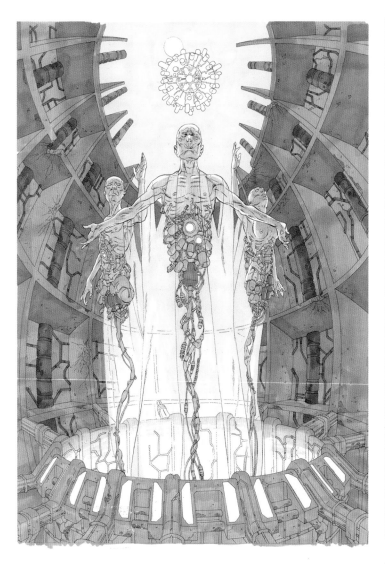

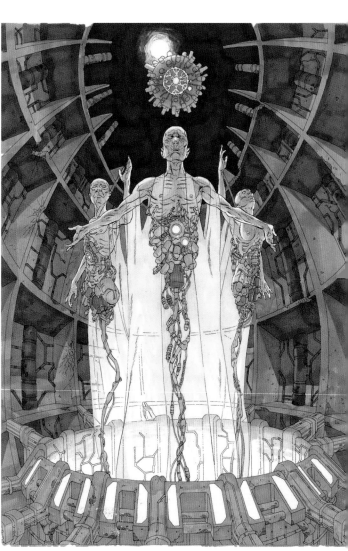

Here I'm starting on a color study, done with markers on a photocopy of the final line art. This will guide the final digital coloring.

The final color study, done with markers, with brightness/contrast adjusted in Photoshop. Blue is associated with spiritualism, so I used a lot of it.

I then scan the final line art at 600 dpi (saved as a jpeg) and open it in Photoshop. Here I'm laying in masses of color.

Working on details of the leader robot. Here we see all the selections I've made and stored for this piece.

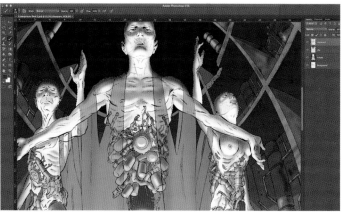

Using a soft brush with low opacity for rendering skin.

Working on details of the priests. I used the dodge/burn tool to get the lighting effects on the tech parts.

May 2080: Somewhere over the Amazon

Traditional armies no longer exist. Interests of all kinds—political, economic, social—are defended by small teams of exquisitely trained mercenaries, laden with the most advanced weaponry corporate cash can buy. Here we see a team in the employ of an ecotourism conglomerate, about to make a midnight landing somewhere in the besieged Omagua region of Peru. Their mission: to have a quiet conversation with members of an unlicensed logging operation.

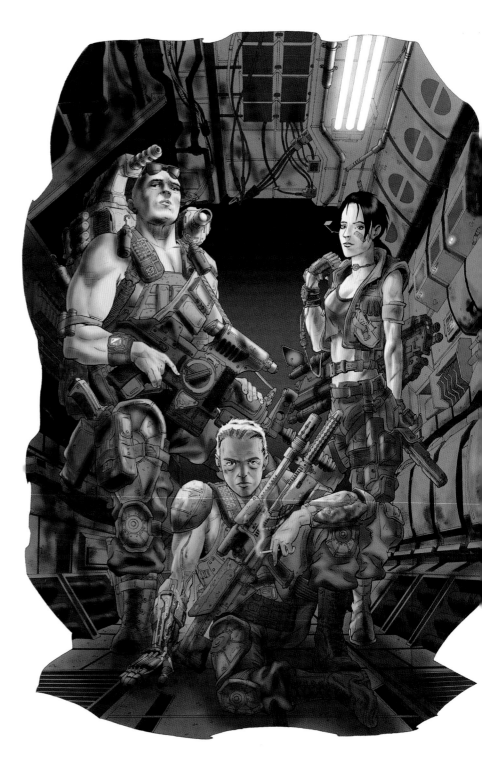

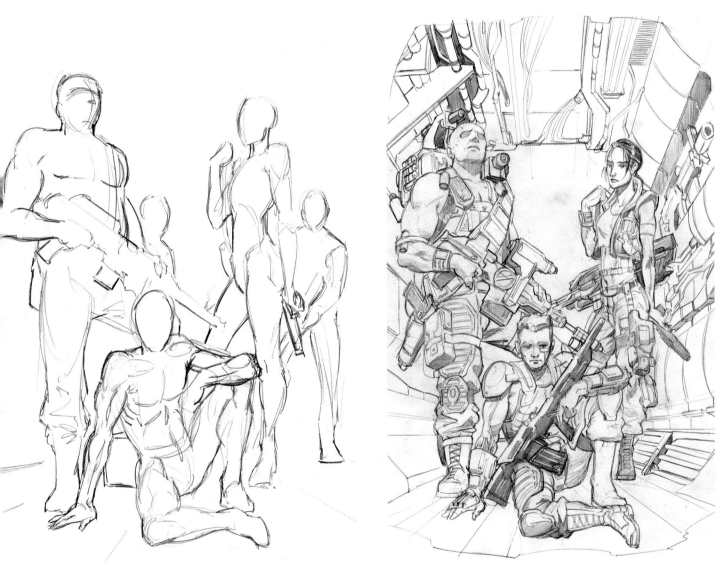

The initial rough of this piece. I'm just blocking in figures at this stage; note that there were originally five.

A much more detailed rough. I've gotten rid of the two extra figures and added a lot of detail; this will guide the final pencils.

Final pencils on Bristol board. To do this I taped the detailed rough to the back of a sheet of Bristol board and put both sheets on my light box. I also used lots of photo references for this image—pictures of body armor, weapons, clothes, and boots, and the actors I cast as the soldiers—all found easily on the Internet. Using photo references is crucial for realism and authenticity.

Final pencils. When doing the background I was looking at a book of Syd Mead's sci-fi concept art for inspiration. The masking tape visible at the bottom is holding the detailed rough to the back of the sheet.

Beginning to ink. Left: I start with the figures, mostly using dip pen and india ink. Right: Finishing the figures using Rapidographs.

Doing the background. Left: I use Rapidographs and drafting tools for all the tech stuff. Right: The final inks, after extraneous pencil marks have been erased. Note that central, more prominent elements are more heavily inked.

DEMO

I scan the final line art at 600 dpi, save it as a jpeg, open it in Photoshop, and save it as a Photoshop file. Here I'm starting to color with Photoshop, just dropping in warm and cool masses. "Marching ants" show that I'm working with a selection for the far background.

Articulating the background. I invested a pretty good amount of time in making little selections.

The background is coming together even more. Why did I do the background first? No reason, just felt like it.

Finally working on the figures, using the brush tool and dodge/burn tool for the skin and clothes.

October 2290: Apocalypse Survivors

A family—descendants of the survivors of the global disaster that smashed the world a century earlier—huddle for warmth in a makeshift shelter. No one knows for sure what happened—an asteroid? A war? No records survived, and the truth is gone from living memory. It doesn't matter anymore anyway.

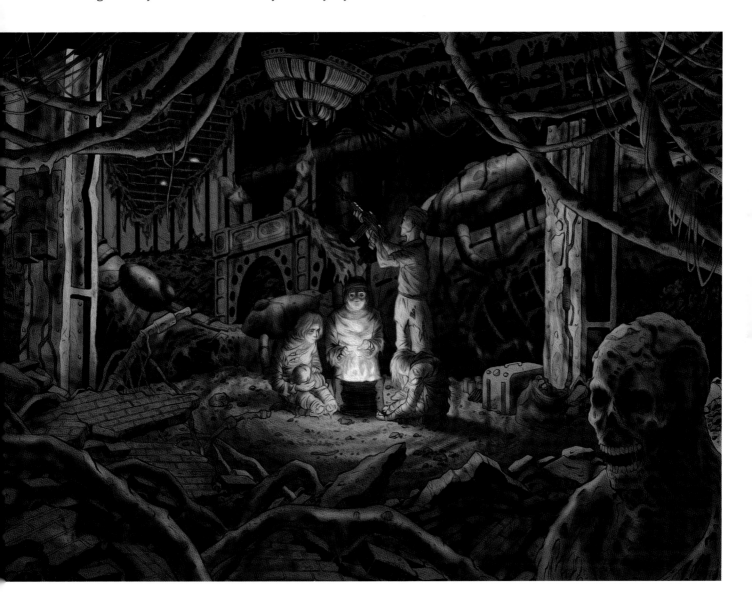

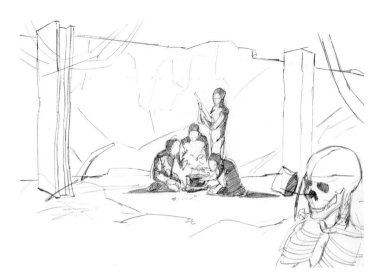

Initial rough of the piece: just indications of a setting, a family group, a light source, and an interesting foreground element (the skeleton).

Here I've taped the first rough to the back of a larger piece of paper and put both on my light box. The first rough "ghosts" through and acts as a guide for a second rough, done with felt-tip pens.

BELOW LEFT: Second rough done with felt-tip pens taking shape.

BELOW RIGHT: Putting down ideas for the far background with pencil.

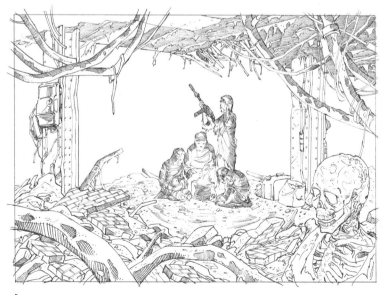

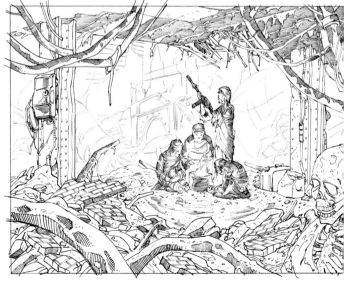

Science fiction is awash these days with images of survivors picking through the remains of their pulverized civilization. Sometimes the devastation has come from space, sometimes it's homegrown (war or a zombie-creating virus). In this piece I wanted to emphasize the unity of this family through warm light surrounded by darkness, and by enveloping their living circle on all sides (including foreground and far background) with death and devastation. This picture is about life reasserting itself, a weed poking through the asphalt.

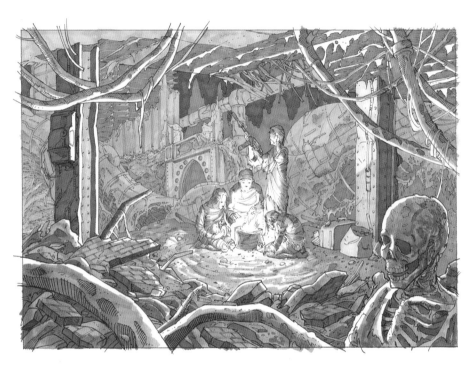

A gray "tone test" done on a photocopy of the second rough, done with markers, to be used as a guide for the final image.

Here I've taped the tone test to the back of a new sheet of Bristol board, and put both on my light box. The tone test "ghosts" through, and acts as a guide for the final pencils, which are here under way.

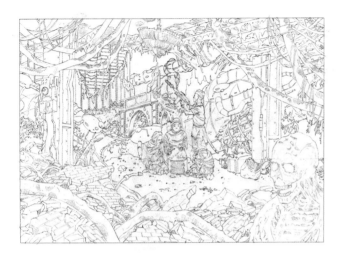

The resulting final pencils.

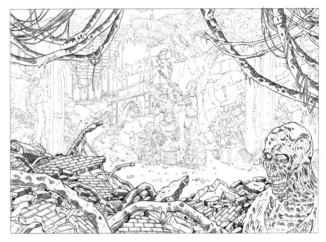

Inking the final pencils with dip pen and Rapidographs.

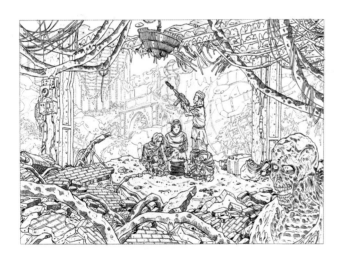

Continuing to ink. All the little x's everywhere, for example in the skeleton's eyes, are reminders to myself to add black ink with a brush later.

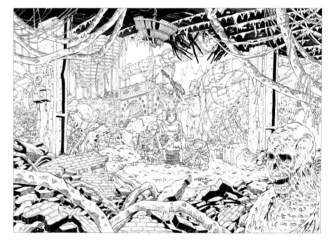

The final inks, after I've erased pencil marks. I added lots of detail to the final pencils, all on the spur of the moment. I was looking online at stills from *The Walking Dead* while doing the skeleton.

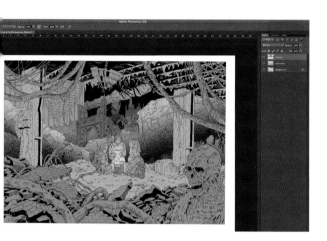

I then scan the final inks at 600 dpi (saved as a jpeg) and open in Photoshop. Laying in masses of color with the selection and gradient tools and the edit > fill option.

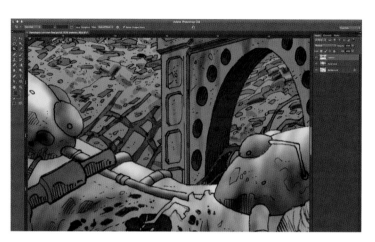

Adding detail to the background debris field.

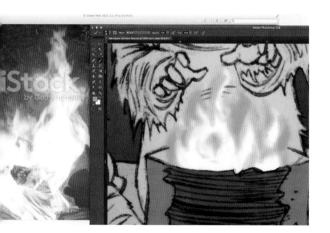

Using a campfire image found online as reference for the fire.

Using a small soft brush in darken mode to render shadows on faces.

November 2074: Christmas Shopping, New York City

A family lingers at a window of Saks Fifth Avenue as maglev cars float by. Inching gingerly up 50th Street is a tourist leisure/tour urban yacht, and heading south down Fifth Avenue is an NYPD patrolman on his beat.

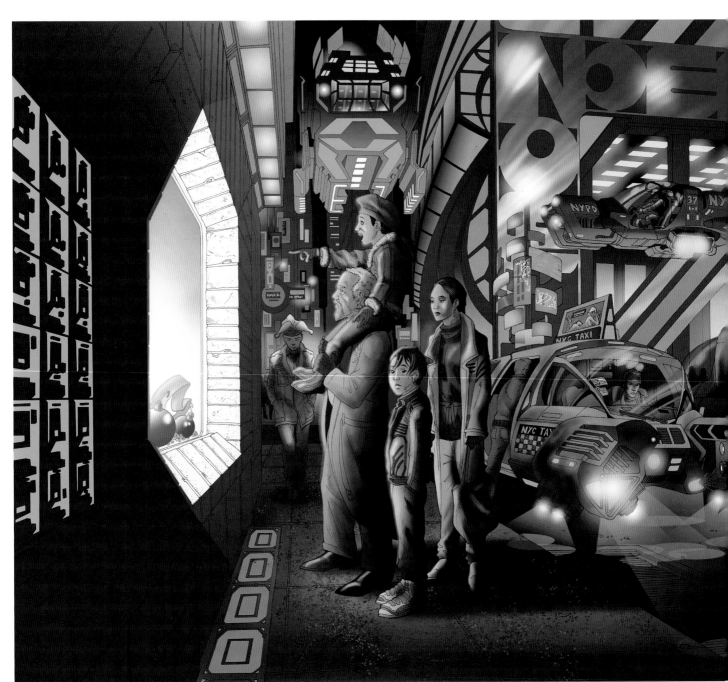

I'd call this utopian; if New York City survives to look like this one day, it would be a fine enough thing for me. I wanted to give this image a Norman Rockwell tilt through the attitudes of the children. Change the set decoration—the cars, clothes, and buildings—and this image would be right at home in 1884. Our accoutrements change, but never human nature. This image is very much the bright opposite number of Apocalypse Survivors (see page 61).

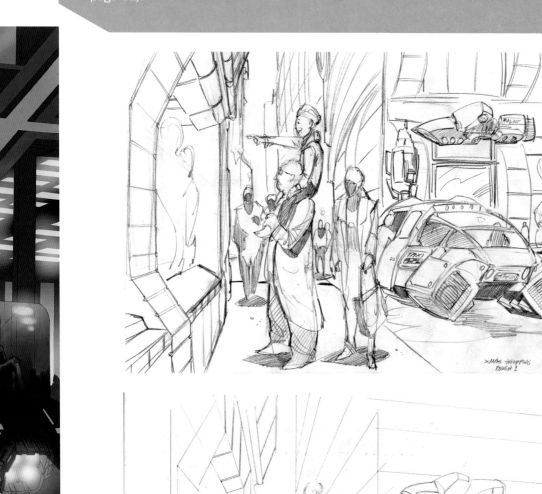

The initial rough for this piece. I did it very quickly and off the cuff, but most of the elements survived into the final.

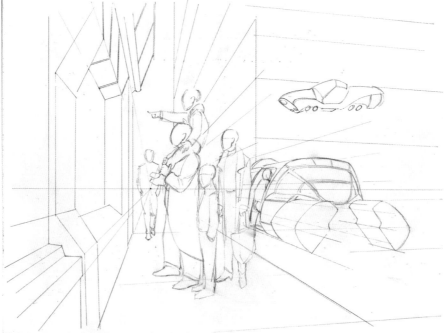

Beginning to work on the pencils, laying everything out with perspective. Only at this point did I add the little boy; it just occurred to me that this piece would work better with a bored kid looking at us.

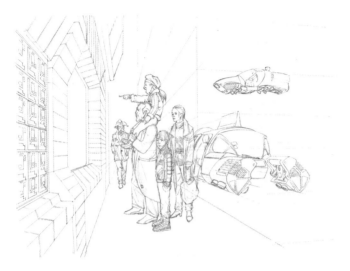

Continuing with pencils, fleshing out the people.

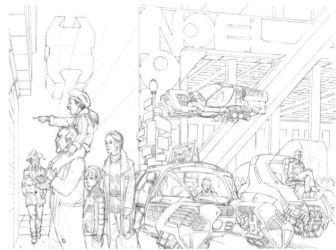

And articulating the background. I was looking at Syd Mead concept art and photos of New York by night for inspiration.

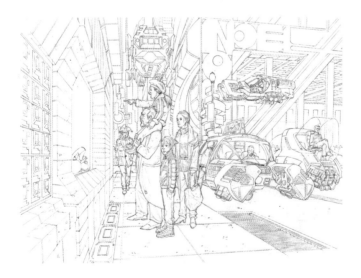

The final pencils, ready for inking.

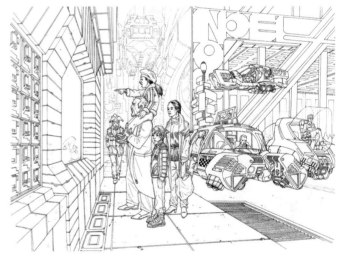

Starting to ink, with dip pen and india ink and Rapidographs.

The final inks, after pencil marks have been erased.

Making an initial color study with markers. I do this on a photocopy of the final inks.

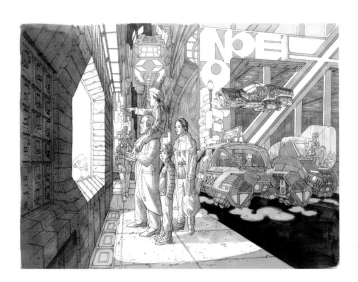

I continue to layer color with markers.

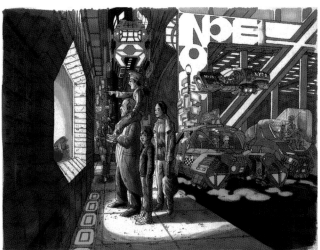

Final marker color study, after brightness and contrast have been adjusted in Photoshop.

I then make a 600 dpi scan (saved as a jpeg) of the final inks and open it in Photoshop. Laying in masses of color.

Using the gradient tool and soft brush to bring out shadows and lighting transitions.

Working on details of the vehicles.

Here I'm laying in a blue tint over everything except the family, just to unify the image. I did this by going to edit > fill (multiply mode), with a 15 percent opacity.

August 1940: Euston Hall, Suffolk, England

George Henry FitzRoy, the Earl of Euston, poses with his wife, son, and father days before his deployment in what will come to be known as Phase Two of the 20th-Century Planetary War (or 20CPL). His father, James, the Duke of Grafton, lost his arm in Phase One twenty-five years earlier. This portrait includes their beloved hound, Isotope.

Not all science fiction is set in the future. Some is set in alternate presents, or even alternate pasts. This image is from an alternate past of the steampunk variety. The steampunk aesthetic posits a world in which steam and other Victorian-era technologies, fashions, and practices evolved and triumphed, up to our present and beyond. It is mainly defined by the look of its technology and its costumes. Steampunk sci-fi imagery is as soot-dark as the milieu that inspired it.

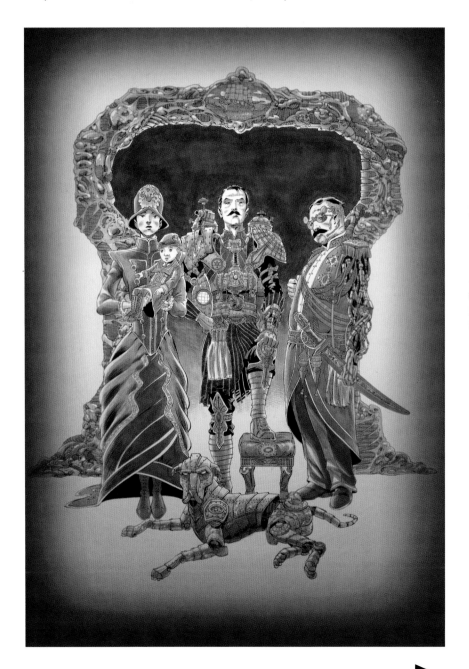

The initial sketch for this piece—little more than a few body types and poses.

A more finished rough. Note the indication of the dog at bottom; this was an afterthought.

Adding the dog. I found a picture that I liked on the Internet, printed it out, taped it to the back of the rough, and put it on the light box. The image ghosting through guided my drawing.

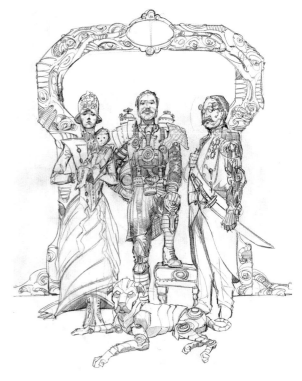

Final detailed rough. I looked at a lot of reference photos online for guidance with this piece—photos of Victorian-era clothes and lots of steampunk artwork.

I taped the detailed rough to the back of a sheet of Bristol board and used the light box for the final pencils. That's a photocopy of the rough at left, which I glance at for the little details.

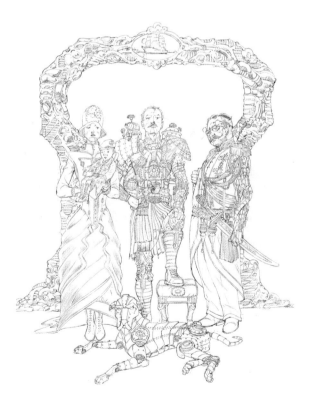

The final pencils.

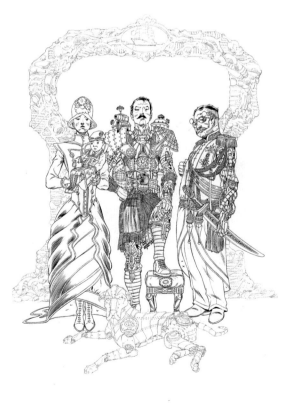

Starting to ink, with dip pen and india ink.

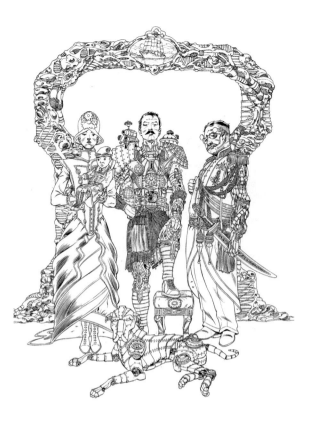

ABOVE: Completing the line work; almost done with inking.

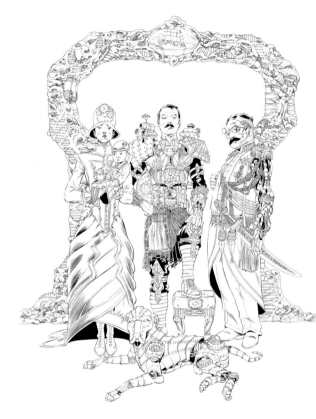

ABOVE: Final inks, after pencil marks have been erased.

LEFT: I decided to color this piece with just markers and to render it in gray tones to mimic the look of an old photograph. Here I'm starting to lay down grays, directly onto the final inks.

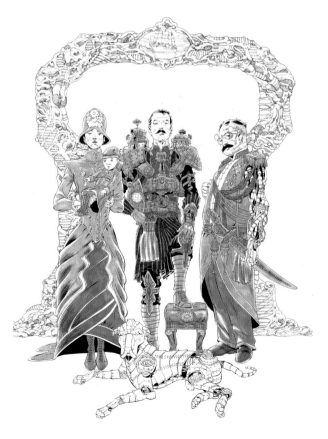

RIGHT: Continuing
to lay down grays.

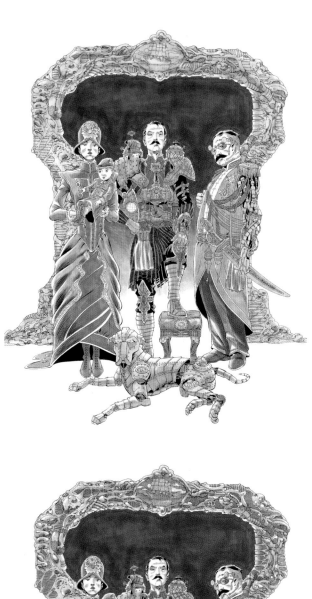

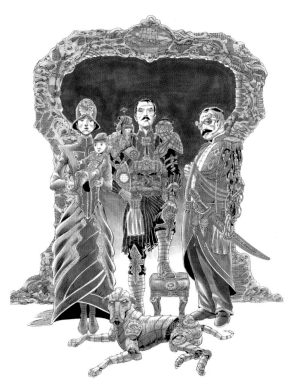

ABOVE: Articulating the background doorframe,
and continuing to darken elements of the
figures.

RIGHT: Finishing details. I added little highlights
with white ink in the background doorframe and
on the dog. I then scanned this into Photoshop,
where I adjusted brightness and color levels and
added the fading border for photographic effect.

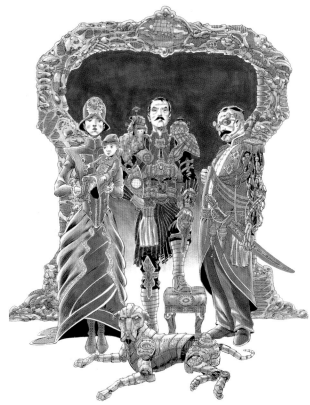

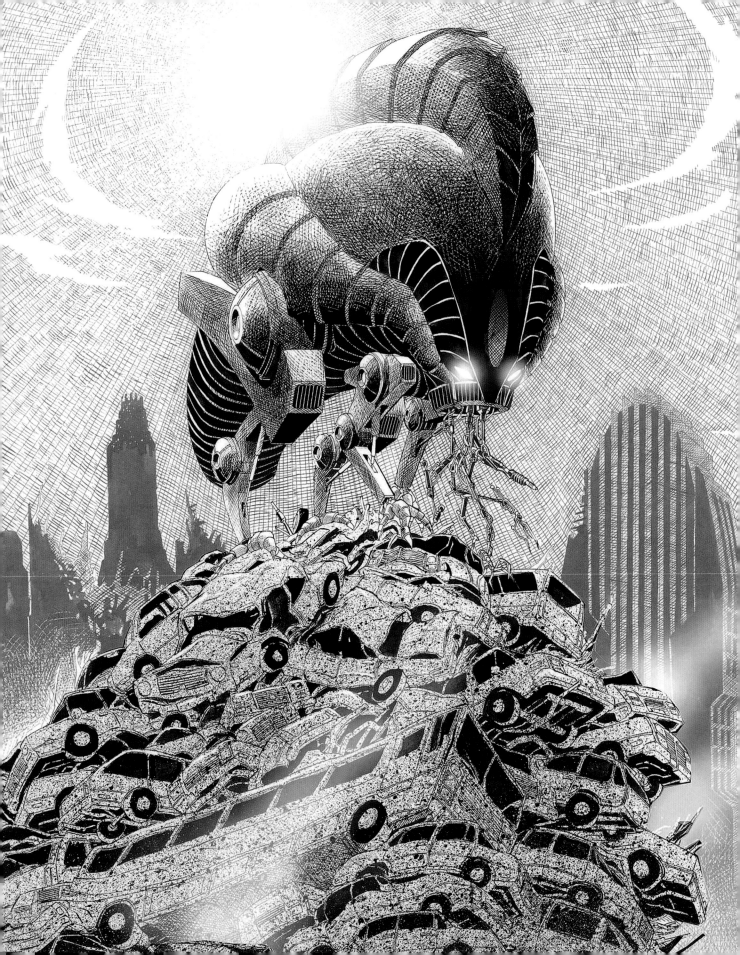

ALIENS & ROBOTS

I've grouped aliens and robots together in this chapter because of one essential commonality: they are almost always deviations from the human form—either in the direction of terrifying distortion (as in the creature from *Alien*) or, less frequently, in the direction of beautiful idealization (as in the replicants from *Blade Runner*). More often than not the monstrous aliens and robots are visual symbols for ugly and violent impulses in the human subconscious itself—they are warnings. And the beautiful ones are symbols for the untapped potential for goodness and perfection within us all—they are signposts, beacons. But in good science fiction, the real purpose of these always uncanny personages is to get us to reflect on ourselves.

In what follows we will examine the making of six of these creatures of darkness and light.

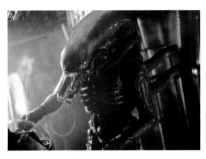

The creature from *Alien* (20th Century Fox, 1979).

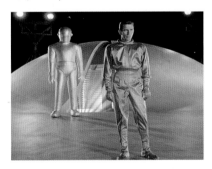

Right: Michael Rennie as Klaatu (good alien) with Gort (bad robot) from *The Day the Earth Stood Still* (20th Century Fox, 1951).

Captain Kirk encounters a Metron in the "Arena" episode from the original *Star Trek* television series (Desilu Productions/Paramount Television, 1967).

OPPOSITE: A SUMA (SUrvival MAchine) (see page 103). A machine with animal-like (or insectoid) design elements.

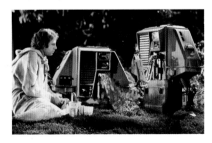

Bruce Dern as Freeman Lowell, with Huey and Dewey, in *Silent Running* (Universal Pictures, 1972).

Summer 8214 (Gregorian): The Imperial Palace, Near Present-day Cairo

Emperor Castrobran IX and his family welcome the emissaries from Mars. The emissaries are not actually aliens. They are human—the result of millennia of artificially accelerated evolution to enable unaided survival on the Martian surface. This program of evolution was instigated by the early Martian settlers late in the twenty-first century, after commerce with Earth abruptly ceased in the wake of inter-Terran war. Now, after several millennia of isolation, they are reestablishing relations with Earth. Their environmental suits keep them sufficiently cold, give them plenty of carbon dioxide to breathe, and enable them to locomote against Earth's powerful gravity.

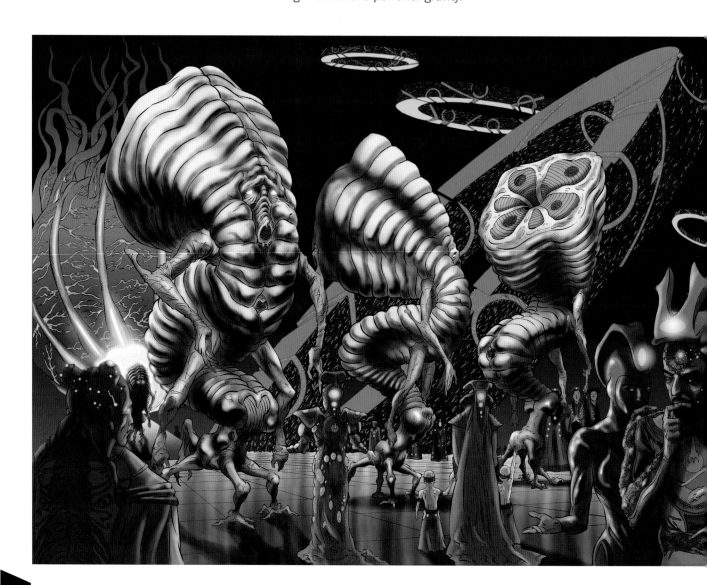

The utopian empire of the distant future is a recurring motif in sci-fi—for example, in the *Foundation* novels of Isaac Asimov and in Frank Herbert's *Dune*. In the scenario presented here, some peculiar human chickens are coming to the imperial home to roost.

An early pass at the Martians. At this point I was picturing them as hostile.

The next sketch, getting closer to the final design.

Continuing to sketch, developing ideas about the setting.

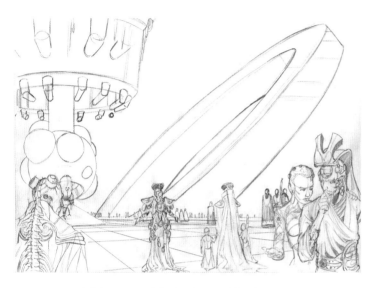

I did a rough of the background/setting on a separate sheet; it just seemed easier, given the complexity of the drawing.

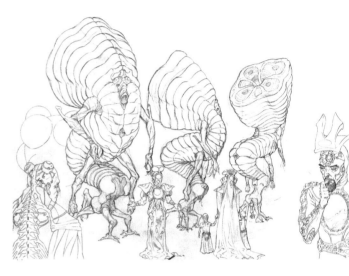

I taped the background rough to the back of the aliens drawing, put both on the light box, and continued on.

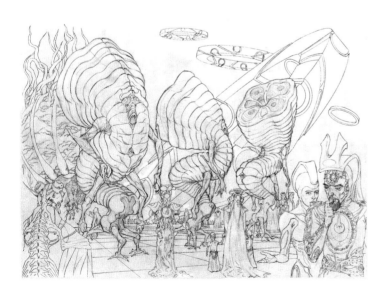

The final pencils.

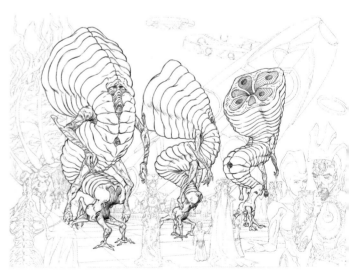

Starting to ink. I begin with the organic elements, using dip pen and india ink.

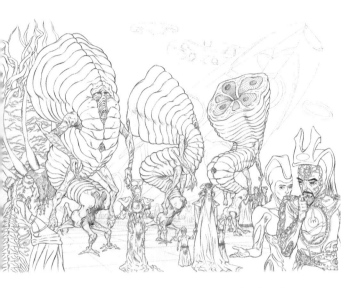

Moving onto foreground elements, still using dip pen.

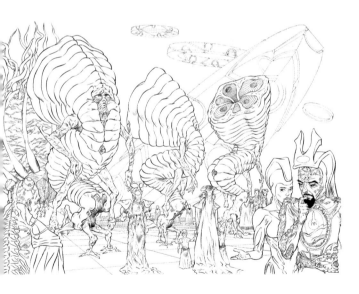

Final inks, after pencil marks have been erased.

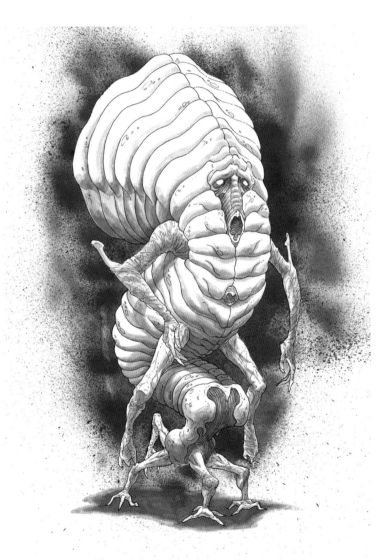

A color study of the Martians, done with markers over a photocopy on bond paper.

I then scan the final inks at 600 dpi (saved as a jpeg) and open in Photoshop. Laying in masses of color.

Rendering the surfaces of the emissaries, with low-opacity soft brush and the dodge/burn tool.

I wanted a light burst behind this guy coming out of his ship. This was done with the gradient tool (in circular mode). I also lightened the black-and-white line art by going into the background layer and using a soft brush with white color.

Working on details of the background ships. I put in those windows with the pencil tool (which gives you as fine a line as you want) and bright electric-blue color.

January 1968: Outside Hué, South Vietnam

Two US infantrymen pose with a Polyphemus-series PISDOFF (Peace-Keeping Insurgent Search-and-Destroy-Operations Fear Fomenter) in the early days of what will be called the Tet Offensive.

Again, sci-fi can take place in alternate pasts. This is one in which the Vietnam War happened, and presumably all the wars preceding it, but in which military investment was heavily concentrated on what's called psyops (psychological operations), influencing the enemy's mind via fear, propaganda, etc. In this reality, giant combat robots have been developed and deployed, in large part for the sheer terror they are meant to create. Honestly, is it any crazier than what actually happened?

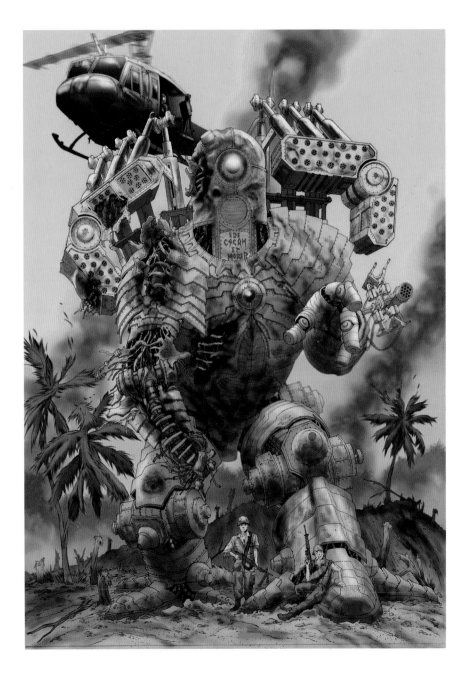

An early rough of the PISDOFF robot described in
my scenario. Little more than shapes here.

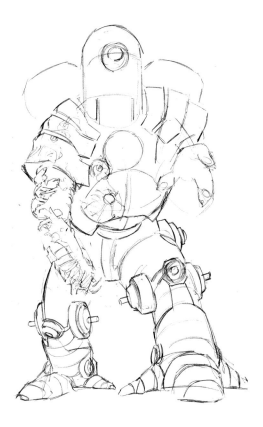

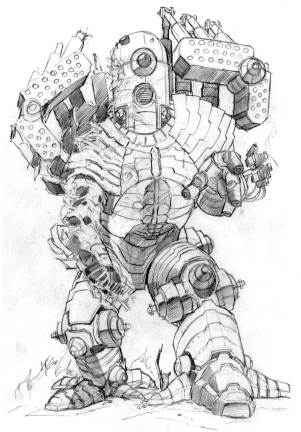

Adding detail to the robot. At this point I decided
that I wanted to show the robot after a battle,
and that it should be damaged.

Finishing the rough, thinking about lighting at
this point.

POLYPHEMUS GEN-5 DEVASTATOR CIRCA 1768

84 HOW TO DRAW SCI-FI UTOPIAS & DYSTOPIAS

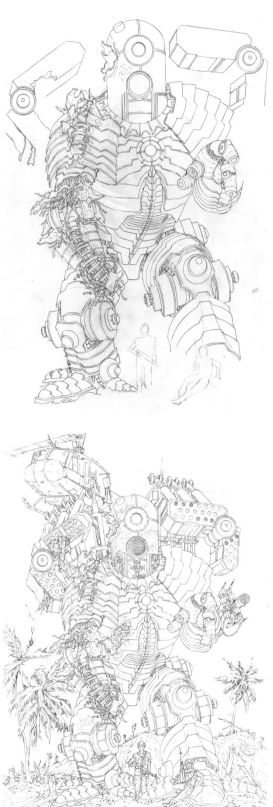

TOP LEFT: I taped the rough to the back of a sheet of Bristol board, put both on the light box, and started doing final pencils.

TOP RIGHT: Pencils developing. At this point I decided to add the soldiers, mainly for scale.

BOTTOM LEFT: I printed out a photo of a Vietnam-era Huey helicopter found on the Internet and used the light box to pencil it in on my drawing.

RIGHT: The final pencils.

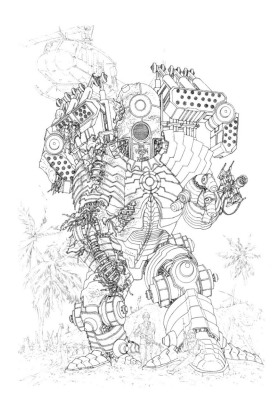

Starting to ink, all with Rapidographs.

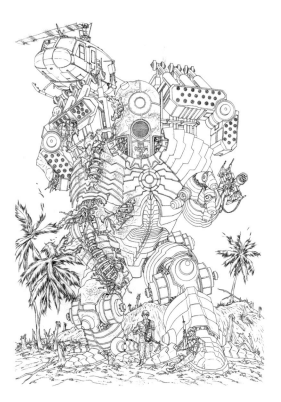

Continuing to ink.

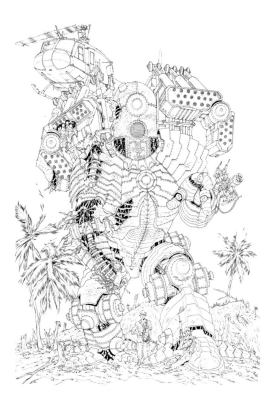

The final inks.

I then scan the final inks at 600 dpi (saved as a jpeg) and open in Photoshop. Starting to color. In the beginning I wanted the robot to be military green.

Working on the robot's face with brush and dodge/burn tools.

Working on the helicopter. Here I've used the selection tool to isolate the windows, and am using the dodge tool to get those light reflections.

Adding details to the soldiers. At the end I decided that I wanted the robot to be military tan instead of green. To do this I loaded the previously made selection for the robot and changed the hue by opening image > image adjustment > hue/saturation/brightness.

November 2359: Epsilon Eridani 3A

This biomechanoid was imaged by an unmanned probe on November 9 in sector 12b of the equatorial region of 3A. The mean surface temperature in that region is 750 degrees Fahrenheit.

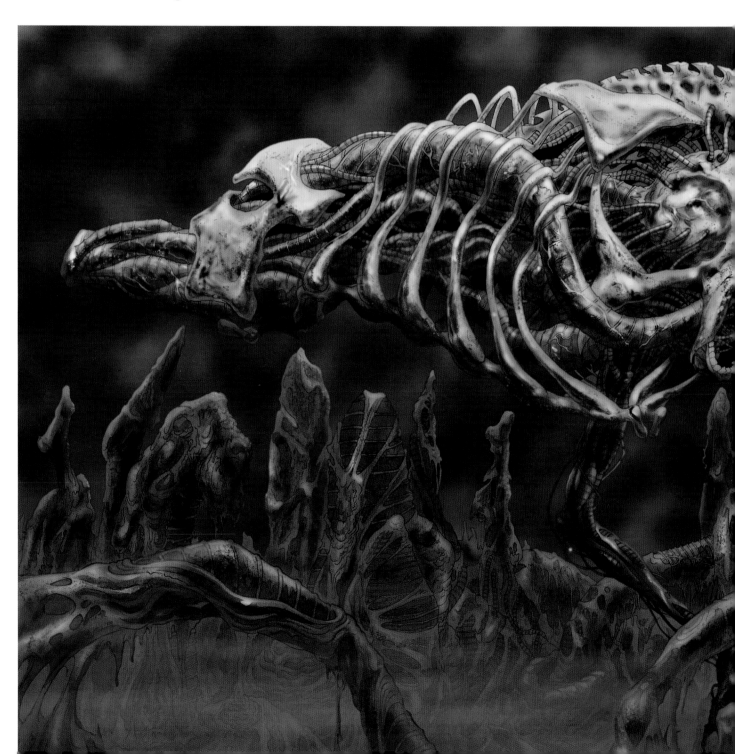

We have cut-and-dried distinctions between things that are alive and things that aren't. An animal is a living organism, a computer is a nonliving mechanism. In science fiction, these pat dichotomies begin to break down. A suitably organized alien might straddle the line between machine and animal, and in the (probably not too distant) future it's going to become an open question about whether or not computers are sentient and therefore endowed with rights.

This piece is in the style of H. R. Giger, whose work very much straddled the line between sci-fi and horror.

Putting ideas down on paper. I had a vague idea of what I wanted here: a floating, vehicle-like organism that was somewhat evocative of a limbless human torso. The horns were intended to give it the feel of a battering ram.

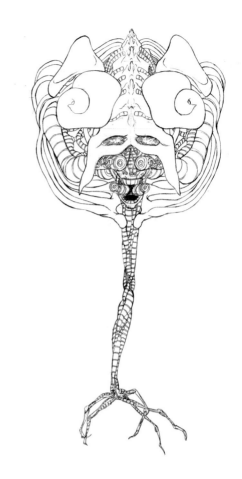

ABOVE, RIGHT, AND BELOW: It gets a little OCD here. I wanted to draw this thing in three-quarter perspective; given that the object is what I would call "wiggly," I decided it might be easier if I did some schematics. I didn't actually intend for it to get quite this involved, but I was having fun, and there you go. They're all done in pencil.

ABOVE: I did this pencil drawing based on the schematic. The biomechanoid is hovering over one of its own dead. I set this drawing aside, thinking I was done with it.

Months later I took the drawing out and realized that I hated the horns. So, using the light box, I started another pencil version minus the horns.

I decided it needed a more interesting environment, which I've started here.

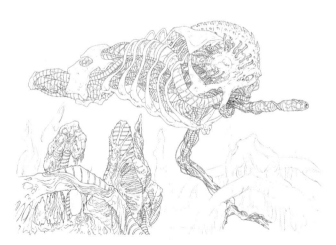

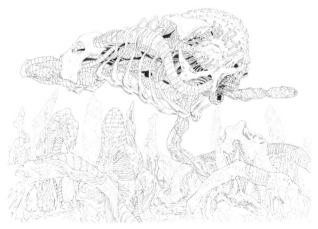

Continuing on. The background forms are also vaguely human in appearance.

Here's the final drawing, inked. I used drybrush (rubbing on ink with a brush that's mostly dry) to put those shadows on the "bones."

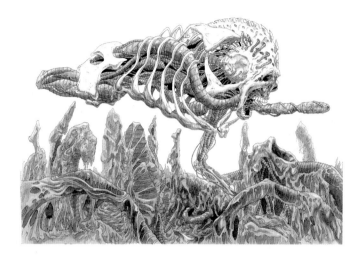

I decided to put an ink wash on the creature and background as a foundation for the color. This was done by simply adding layers of heavily diluted india ink (and some white ink) with a brush onto the original drawing. It took about six hours.

I then scanned the ink-washed drawing into Photoshop. Here I've added a warm gray tint to the entire piece, and am putting in a simple Geiger-esque cloudy sky with a soft brush and brown and white color at low opacity.

Here I've used the dodge/burn tool to further render the creature's bony surface, and am using the blur tool to soften its outline.

Using the soft brush at low opacity, as well as the dodge/burn tool, to render the alien's surface. I've isolated the area of the surface behind those two armlike structures (using the selection tool) and added a layer of mist using the soft brush; this helps create depth.

September 2160: The Surface of NGS-8512-A

On September 6 an unmanned probe recorded this image, and then ceased transmitting for reasons unknown. Most of the surface of NGS-8512-A is covered with ruins very like those seen here. Photospectral analysis indicates that the orb-like object closest to our viewpoint is forty to fifty meters in diameter, and the "construct" (for want of a better word) is more than two kilometers in height. The relationship between the various orbs and the construct is not known. Whether the orbs are mechanisms or alive is not known. Whether the construct is *moving* (as it appears to be) is not known.

All of my favorite science fiction involves thought-provoking but unanswered questions, left as exercises for the reader or viewer. What happened here, and what's happening here now? Life seems to be reasserting itself, but beyond that . . . maybe some things just aren't given to us to be known.

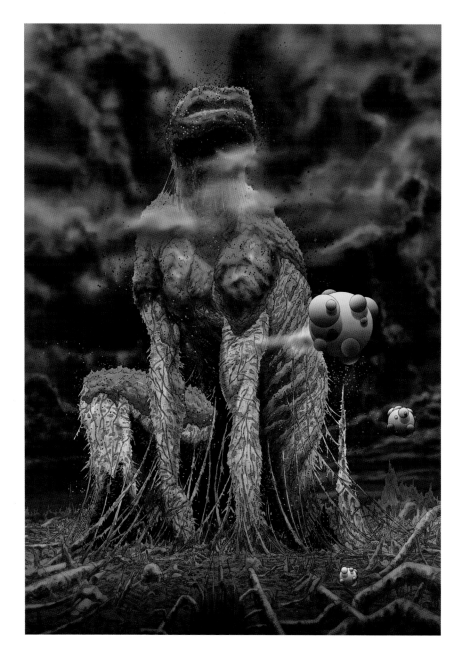

The first sketch. As often happens, I had only a vague idea of what I wanted; in this case it was a humanoid form growing out of some ruins.

The next rough; this one is very close to the final version.

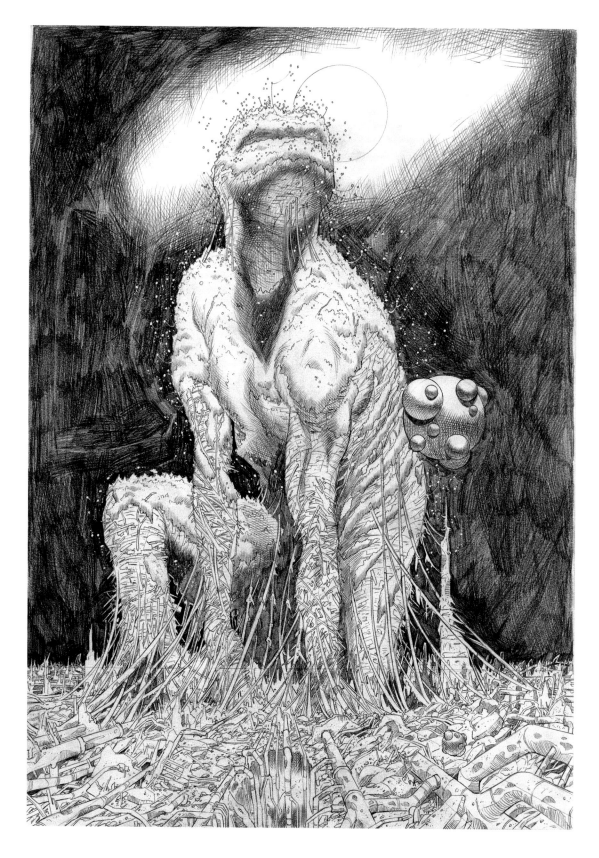

Based on the second rough, I did this pencil drawing. At this point I thought I was done with this piece.

Later I decided this piece had more potential. So
I started doing an inked version, using the pencil
drawing and the light box.

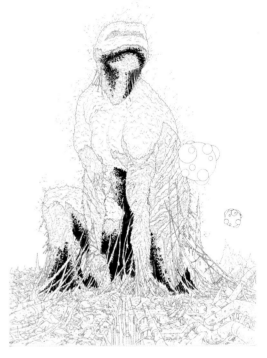

Here's the final inked drawing.

These colors were done with markers, right over
the inked final drawing.

I scanned the first color pass into Photoshop and started from there. This sky effect was done with the gradient tool. I wanted all soothing earth tones for this piece, to play up the theme of reemerging life.

Working on the sky more. The "marching ants" show that I have made a selection for the entire sky (this takes time and patience, but it's worth it). Then I used a soft brush with about 15 percent opacity and started building up the clouds.

Adding clouds both behind and in front of the thing. I wanted it to look truly staggering in size.

I used the blur tool to soften elements near the bottom to create that "pinhole camera" effect.

March 2130: Android Recycling

An android long overdue for recycling is decomposed: the billions of nanomachines of which it is made are programmed to spontaneously dissociate and rejoin the techno-mass of the recycling center. Eventually these nanomachines will recompose into a new android. Two center attendants look on.

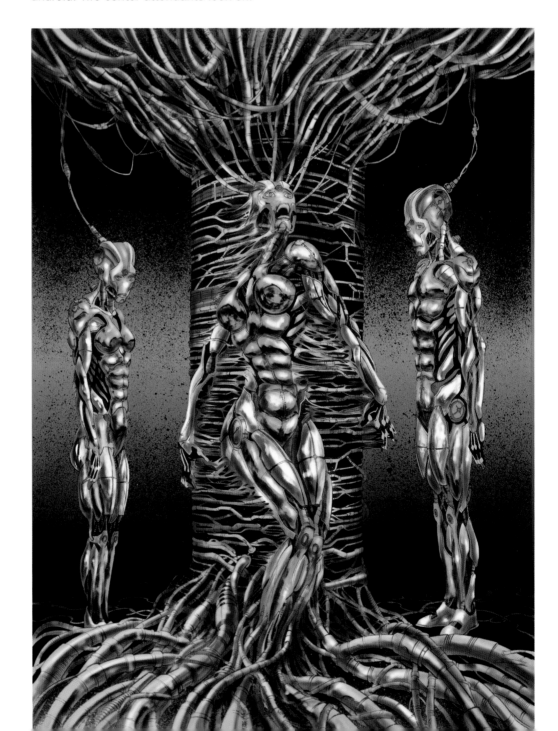

The idea of machine intelligence has been explored in a number of great sci-fi movies. Among those that come to mind are 2001: A Space Odyssey; Blade Runner; Star Trek: The Motion Picture; and A.I. Could a sufficiently complex computer or robot become conscious? Could it feel pain? Or could it only mimic pain? These questions are the exclusive turf of science fiction for now, but eventually they will become urgent questions of science.

Again, utopian or dystopian, depending on how you look at it. I wanted this image to fall pretty squarely in the "cyberpunk" genre—a distinct aesthetic with a very sleek feel, centering around computers/information technology and the creeping corporatization of the modern world.

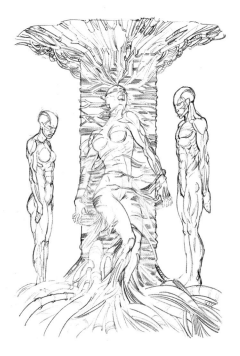

The first sketch. I was going for pure anguish, pure emotion, pain.

Based on that, I started this more involved pencil rough.

Final pencil rough.

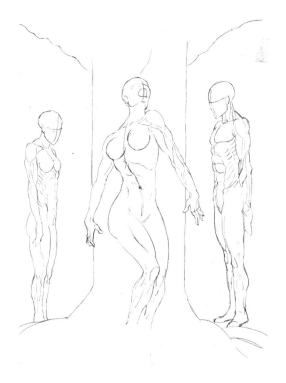

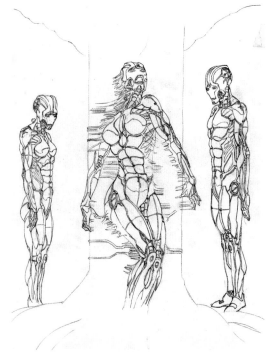

Using that rough and the light box, I started on some final pencils.

Continuing on with the pencils.

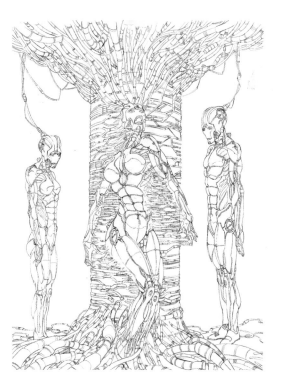

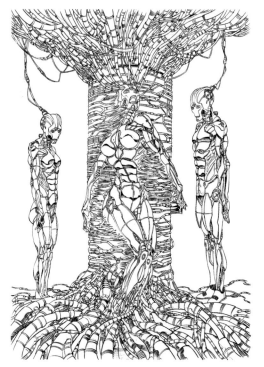

Final pencils.

Working on the inks. All the line work is done here, mostly with Rapidographs.

Using a #2 brush to fill in areas with black india ink.

Masking out areas with masking film. I covered the robots, leaving only the background exposed.

Using a toothbrush and india ink to create spatter effect on the exposed areas. After the ink dries I remove the masking film.

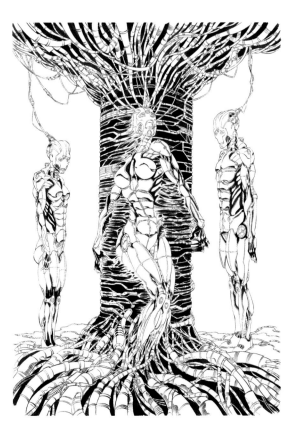

After black bits have been filled in.

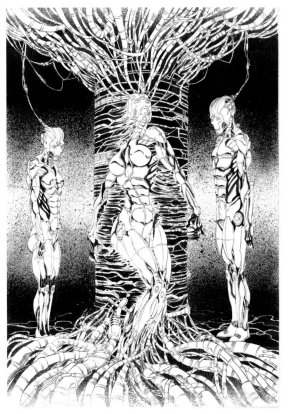

The resulting final inked drawing. This is then scanned at 600 dpi, saved as a jpeg, and opened in Photoshop.

Laying in masses of color.

Putting in red details on the androids. Here I'm selecting a small hard brush with full opacity to do this.

Bringing out lighting effects on the androids. To get a shiny, chromelike appearance, I'm using the dodge/burn tool with a hard tip and almost 50 percent exposure. I switched back and forth between hard and soft tips.

Bringing out lighting effects on the tangled wires/tubes using the dodge/burn tool, just with a soft tip and a soft brush.

August 2050: Los Angeles, California

A SUMA (SUrvival MAchine) wanders through the remains of the city, searching for fissionable material. A small number of these robotic life-support units were developed and sold to superwealthy clients when the U96 virus began to decimate humanity in 2025. Built to comfortably house, feed, and defend a family of five for several years, a SUMA was essentially a mobile, self-sustaining fallout shelter. Though this one's passengers have long since died a lingering death of starvation, it continues to trundle about looking for fuel, its inhabitants' corpses still inside.

Several famous sci-fi movies feature the motif of a robot inheriting the abandoned remains of some dystopian society; think of Wall-E, *Huey from* Silent Running, *and Box from* Logan's Run. *It's an unsettling yet strangely poignant image—are we smart enough to build a robot like that, but stupid enough to destroy ourselves?*

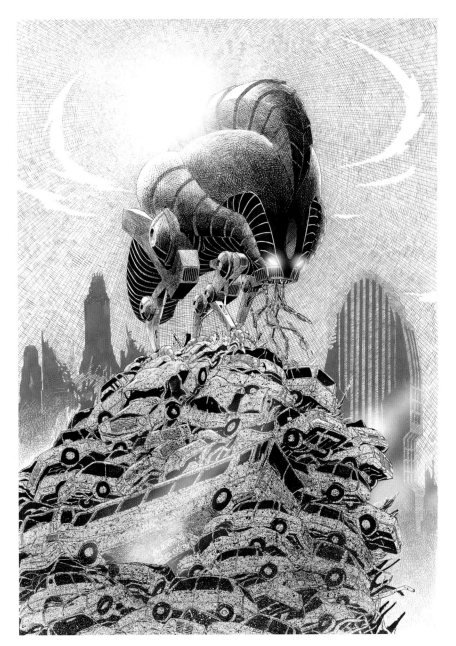

First rough of the SUMA.

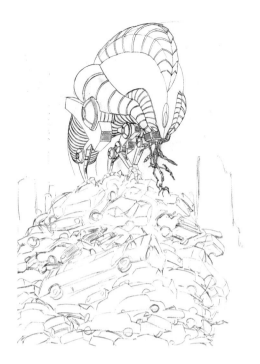

Using the rough and light box, I proceed to create finished pencils on Bristol board. I put the SUMA on a mountain of cars for scale and dramatic effect.

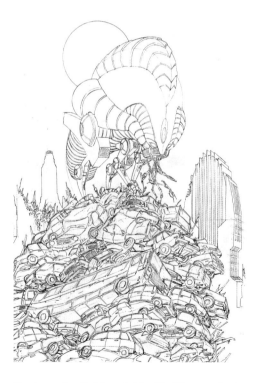

Final pencils. At this point I added the sun that is visible in the rough above. As you can see, I shrank the sun as the drawing progresses from here on.

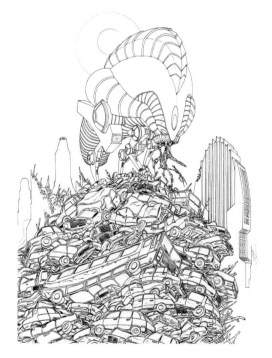

Starting the inks; here the basic line work is all done. I rendered the SUMA with Rapidographs, the cars with dip pen and india ink.

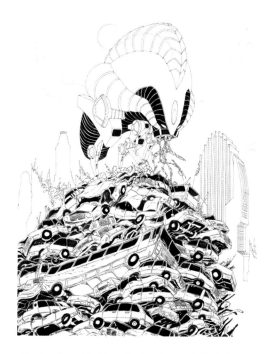

Black bits added in with brush and india ink.

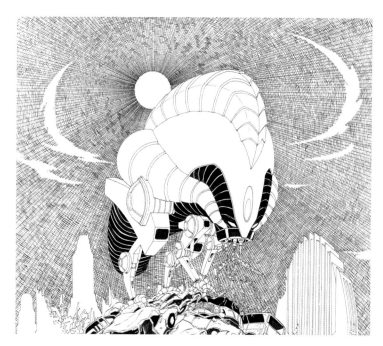

An abstract sky effect added in. Looks overpowering here, but I knew at this stage that I would end up muting it in Photoshop.

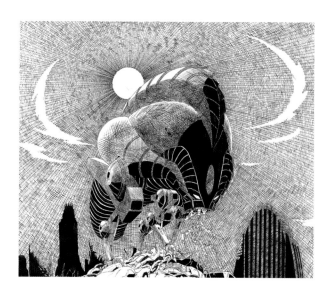

Next I rendered the SUMA's surface in cross-hatch and added parts of the background.

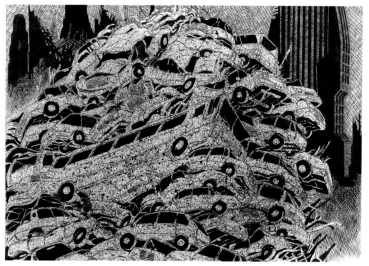

I added the spatter effect to the cars using toothbrush and ink after covering other parts with masking film.

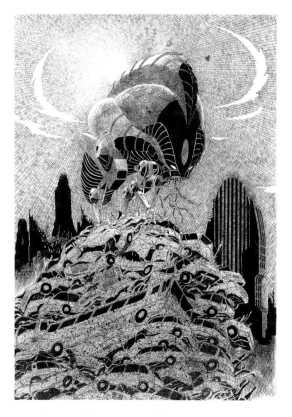

I created the sunburst effect with white spatter.

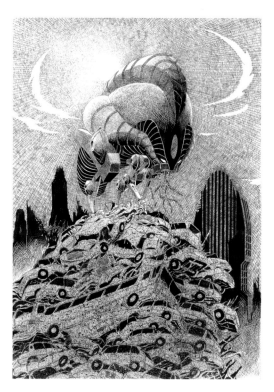

Using a dip pen and white ink, I further elaborated the cross-hatching on the SUMA and background buildings.

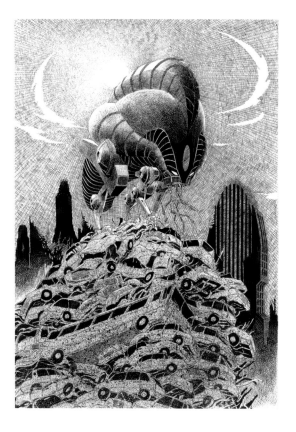

The final inks. The drawing could be called done at this point, but I wanted to gussy it up with Photoshop just a bit more. I scanned it at 600 dpi (saved as a jpeg) and opened it in Photoshop.

"Marching ants" show that I've selected the entire background. I then lightened the background by going over it with a large soft brush with white on 10 percent opacity.

Here I'm adding smoke to the cars. I've used the selection tool to isolate the area with smoke in it, and I'm using a soft brush with low opacity.

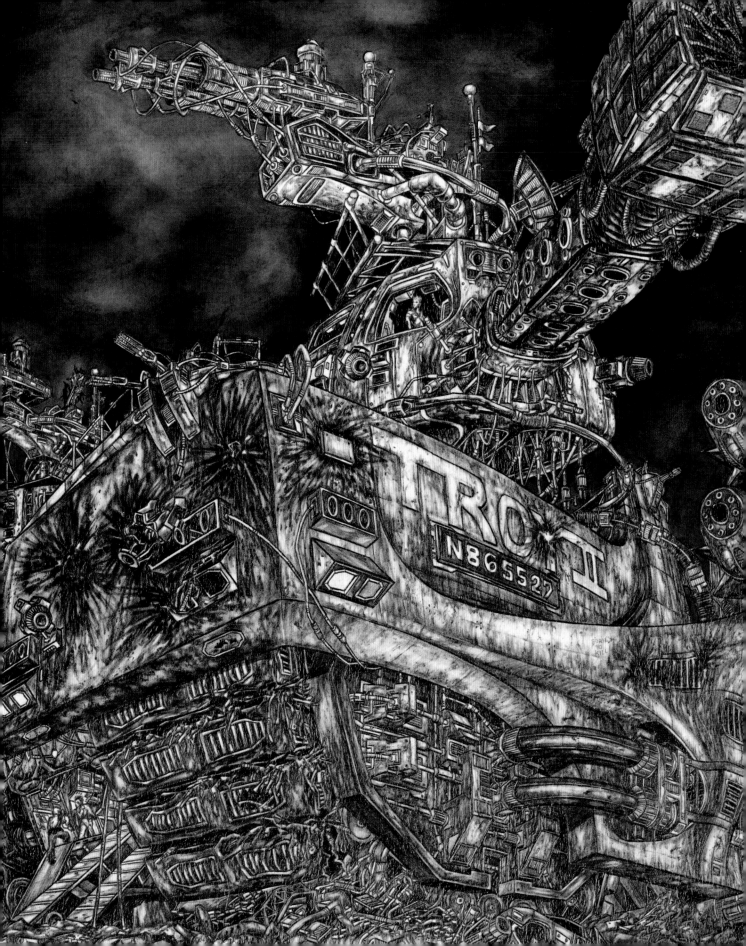

LAND VEHICLES

Rod Taylor at the controls of the Time Machine, from *The Time Machine* (Metro-Goldwyn-Mayer, 1960).

There has always been an intimate connection between people and their conveyances; cars are very much extensions of our own bodies. Whether they are strictly utilitarian or signs of wealth and status, our cars are diagnostic of what we are and do, how we see ourselves. Futuristic cars in utopian science fiction have almost always been characterized by smoothly rounded, gleaming chrome surfaces and quietly humming engines. Car designers have tried to realize these utopian visions (life does imitate art); cars certainly do always seem to be getting smoother and sleeker. But funnily enough, most cars (as of 2016) still house internal combustion engines that are essentially the same as those in the Ford Model T.

A war rig from *Mad Max: Fury Road* (Warner Brothers, 2015).

With 1981's *Mad Max 2: The Road Warrior*, we had the advent of the dystopian car (it had a precursor in the Jawa Sandcrawler of 1977's *Star Wars*). Filthy, rusted out, cobbled together, usually bristling with armor and armaments, a thing of duct tape and paperclips, it was very much an extension of its dystopian driver. True to form, how we represent our cars, our most treasured and relied-upon bit of technology, mirrors the utopian and dystopian leanings of our temperaments.

The *Nautilus* (designed by Harper Goff) from *20,000 Leagues Under the Sea* (Walt Disney Productions, 1954).

Here we will examine the making of some pretty standard sci-fi vehicles, two of which you may already be well-acquainted with: the Time Machine and the *Nautilus*.

OPPOSITE: A pencil drawing by the author, tinted in Photoshop.

A Jawa Sandcrawler, from *Star Wars: Episode IV, A New Hope* (Lucasfilm Ltd./20th Century Fox, 1977).

June 2066: Outside Yuma, Arizona

Maglev cars have been in wide use for several decades now, and ground traffic is confined to a relatively small number of vehicles that are too heavy to fly, like this one, the Susomi Titan RXL. Measuring 30 feet high, 20 feet wide, and 102 feet long, it weighs in at 145 metric tons (when fully laden), and is powered predominantly by solar energy. Because of its bulk, this vehicle's "cab" is actually an apartment that

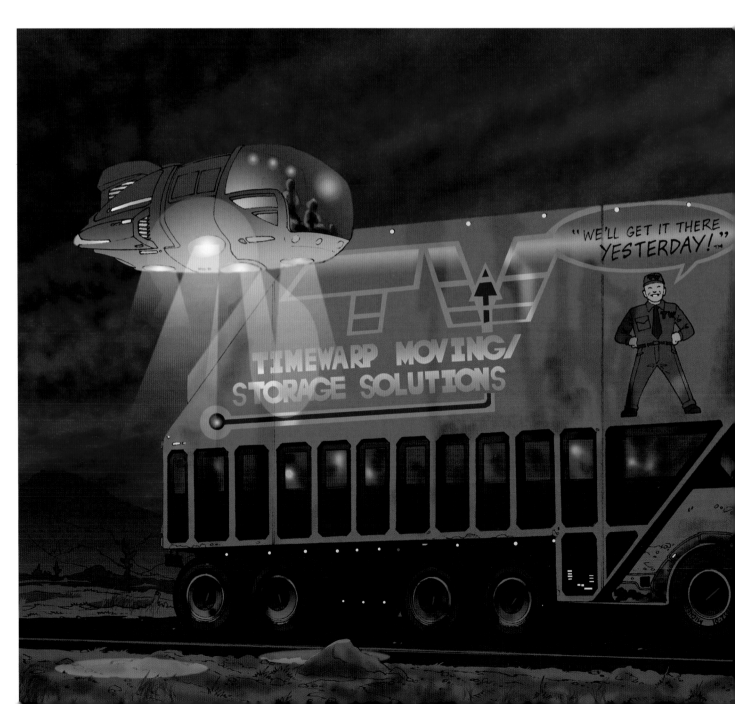

accommodates a family of four full time. Their home is the road; the children are educated online, and they have friends at weigh stations and ports of call from coast to coast.

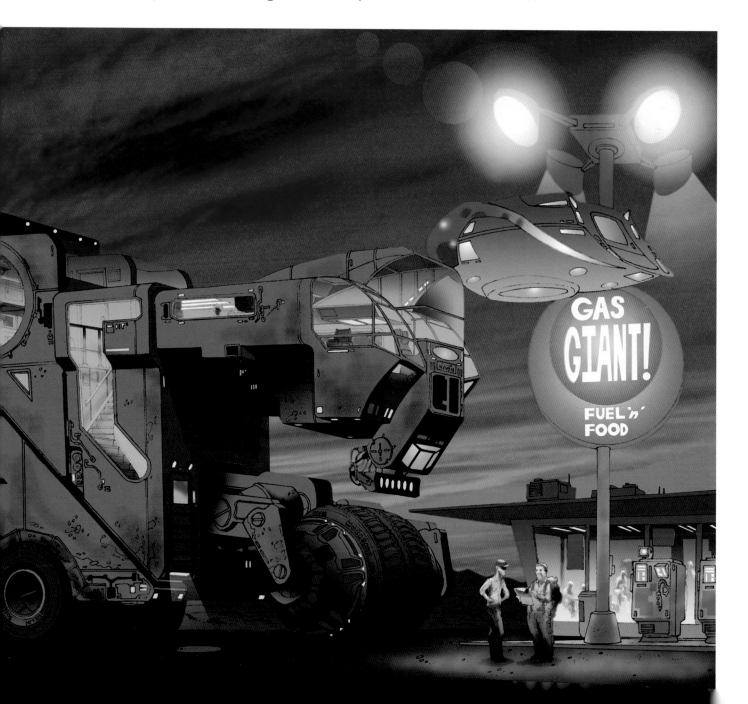

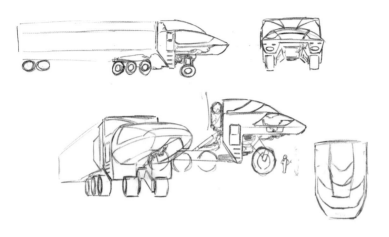

Beginning to work out the basic shapes, using perspective.

The very first concept sketches for this piece.

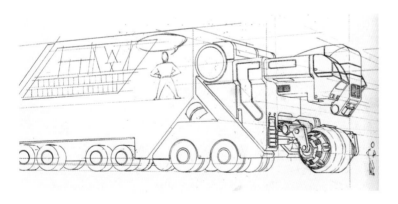

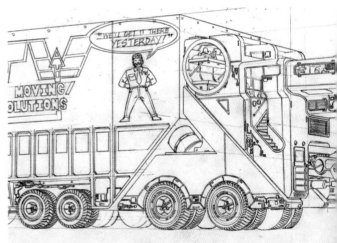

Adding details and wheels, and the figure for scale.

Finishing the truck in pencil. I was looking at photo references of actual trucks and tires, and Syd Mead artwork, for inspiration.

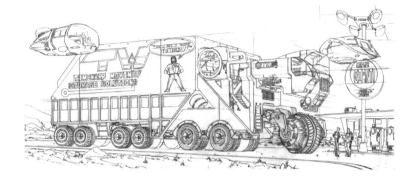

The final pencils. Putting the truck in the desert was an afterthought; originally it was going to be in an urban setting. This way meant less work for me. Plus, I have lovely memories of the Arizona desert and wanted to draw it.

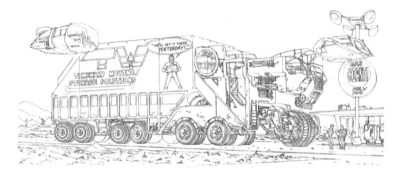

The final inks, done mostly with Rapidographs. Obviously this is a highly technical drawing, and I relied on rulers and oval templates throughout.

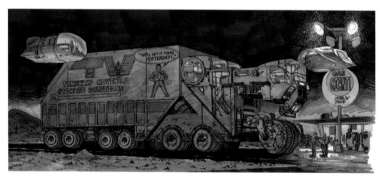

A quick color study (it took about ninety minutes), done with markers and white spatter over a photocopy of the final inks, to guide the final coloring.

I then scan the final inks at 600 dpi (saved as a jpeg) and open in Photoshop. Starting to color, I did a sunset sky first, using the gradient tool.

Continuing to drop in big masses of color. Again, those nice color transitions on the ground and in the floating cars were easily done with the gradient tool.

Working on the text on the truck. Here I'm loading a selection previously made and stored before I began to actually color.

I decided that I wanted a more believable sky. So I downloaded this photo from iStock (istockphoto.com) for about seven US dollars and loaded it into Photoshop. I then adjusted the sizes of the two images so that they were about the same, pasted the truck and desert over the sky, and used the free-transform tool to adjust the positioning. Looks much better.

Finally, I added little touches like these light beams. I just selected the area of the beam and used the gradient tool with white color on a very low opacity.

June 2066: Interior of the Susomi Titan RXL

The Titan truck apartment cab boasts four hundred square feet of living space and can comfortably house a family of four. The dining table and two stools can recess into the floor to create more living space when needed, or enable the sofa at right to fold out into an extra bed. The bathroom (not shown here) is beneath the children's bunk beds, and the parents' bedroom is to the right of the kids' room. The vehicle is self-driving, hence the lack of a steering wheel. All the windows can be tinted for privacy.

Again, this was inspired by the work of Syd Mead. I wanted to create a sense of comfort, coziness, homey intimacy, and ergonomic efficiency. Families of more than four live in much less space the world over right now.

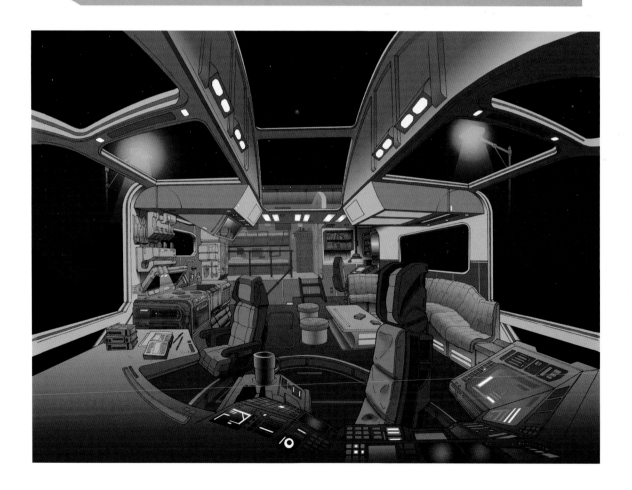

The first rough of this image, working out basic shapes with perspective. Originally there was going to be a kid on the floor.

Doing the final pencils. The rough sketch was taped to the back of this so that I could use the light box.

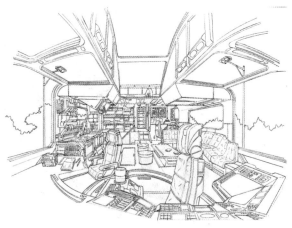

Continuing with the pencils. I was looking online at photos of yacht interiors and Syd Mead artwork for inspiration.

The final pencils.

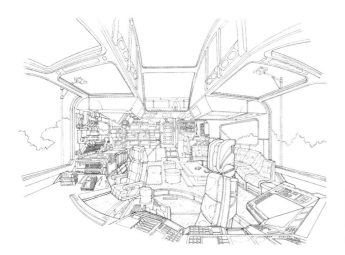

The final inks. Note that the line weights decrease for objects that are farther away. I used the stipple method to indicate the carpeting texture.

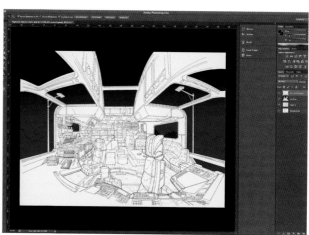

I then scan the image at 600 dpi (saved as a jpeg) and open in Photoshop. Starting to color, laying in big masses.

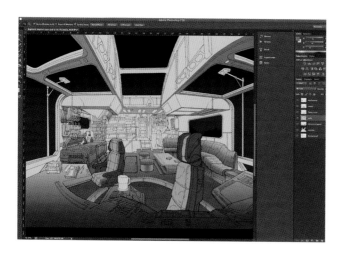

Articulating the furniture, adding shadows with brush and gradient tools.

Working on the bedrooms. I wanted a very soothing look for this image, so I went with earth tones—beiges, browns, greens, and blues. Note that in the final image the foreground seats are shades of green; this was done to create depth. I didn't have to recolor them—I just reloaded the appropriate selection and used the image > adjustments option to alter the hues.

June 2180: Arrival of a Landship, Kansas City

Kansas City is surrounded by hundreds of miles of desiccated wasteland; thus the war survivors there have lived in relative safety for several generations. Once in a great while their routine is broken by the arrival of a landship, sometimes for purposes of barter, sometimes for attempted but never successful conquest. This landship is built atop the remains of a battle wagon of unknown origin.

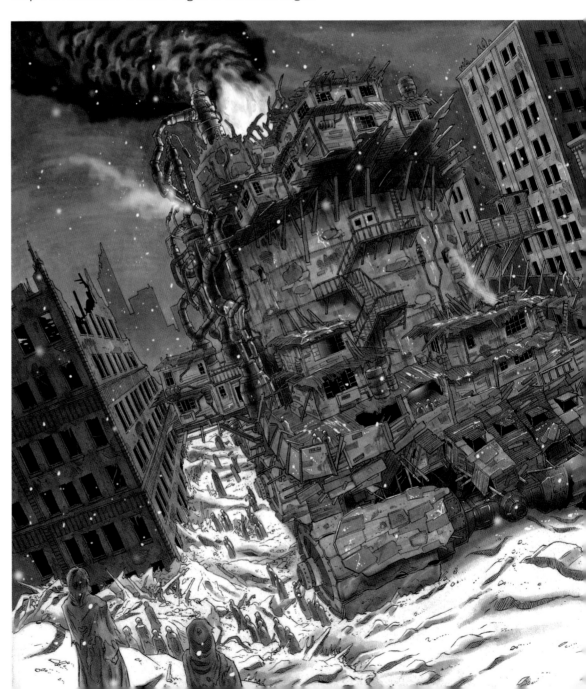

A scene from the dystopia of war and human folly. Could something like this actually be built and operated in a situation of universal scarcity and ignorance? Absolutely not. But the contrast of the semi-intact city street and the rickety, grotesque behemoth trundling down it makes for a very compelling science fiction image.

Beginning of the initial rough.

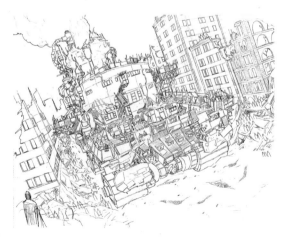

The completed initial rough.

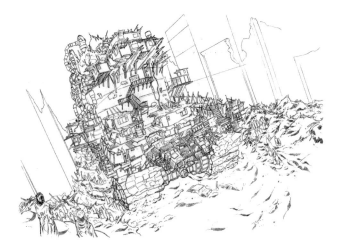

I taped the initial rough to the back of a sheet of Bristol board and started doing final pencils with the light box.

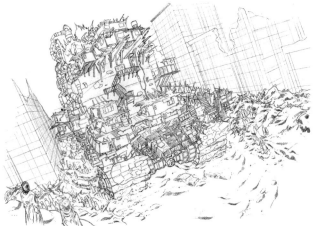

Penciling in the buildings with perspective.

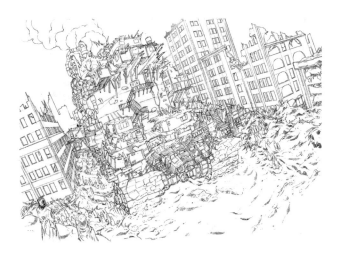

Final pencils, ready for inking.

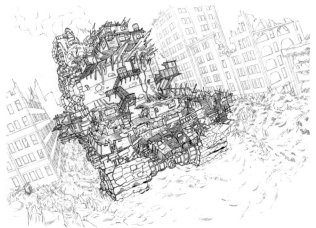

Starting to ink first the vehicle, with Rapidographs.

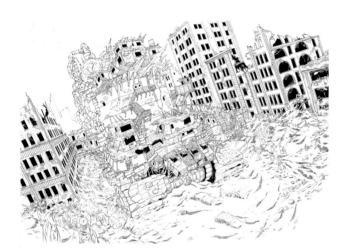

Final inks.

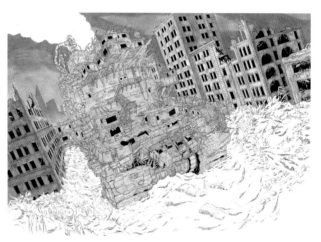

I decided to color this piece with markers and to use mostly gray tones to make it grim and wintry. The coloring is done directly on the final inks.

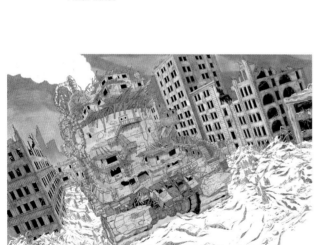

Continuing to color with grays.

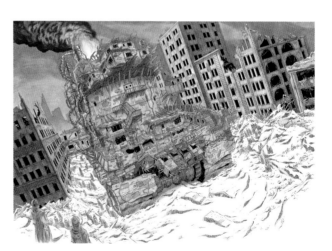

Adding smoke and fire for highlight/dramatic contrast, and some white ink on parts of the vehicle for bits of snow. I then scanned this into Photoshop, added falling snow, some smoke, and spotlights, and adjusted the brightness and contrast.

March 1898: The Mediterranean Sea, South of Crete, 34°27' N, 24°52' E

The *Nautilus* hovers over the remains of a British warship that has just sunk. Captain Nemo and several members of his crew are scouring the wreck and the surrounding debris field for anything usable.

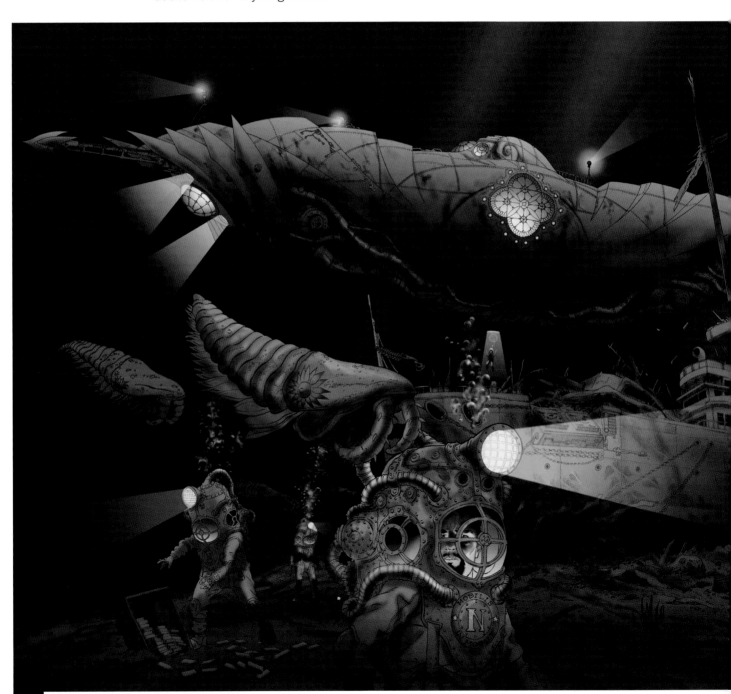

The Nautilus *is one of science fiction's most iconic vehicles. Part oceangoing research lab, part avenging death ship, it is very much an extension of the mind of its master, the great sci-fi villain Captain Nemo. It has been redesigned many times, but its most recognizable version was that created by Harper Goff for Disney's film adaptation of Jules Verne's 1870 classic,* 20,000 Leagues Under the Sea, *which many consider to be the first proper sci-fi novel. Goff's rendition is the "patron saint" of the steampunk movement. Here is my interpretation.*

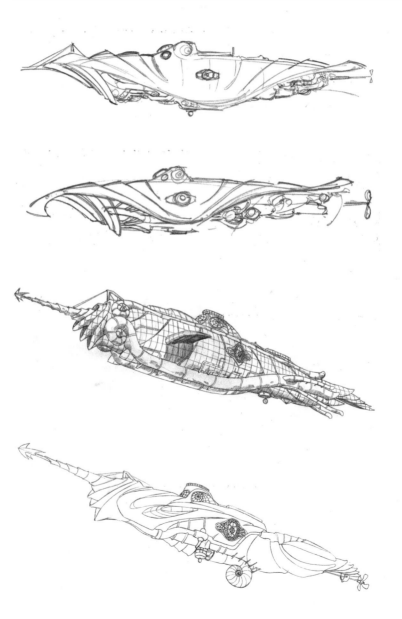

Various early sketches. The final version incorporates elements from all of these.

Beginning the pencils of what will become the final version.

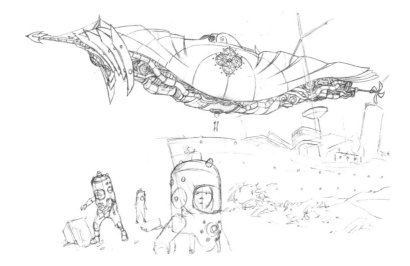

Adding background elements, roughing-in the figures.

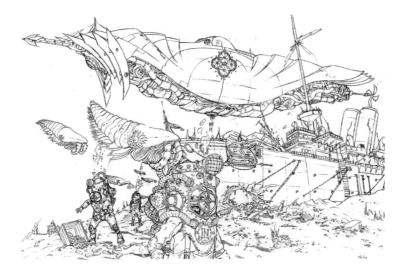

The final pencils. I used reference photos of 1890s-era British warships, those strange sea creatures, and primitive diving suits, all easily found with Google and essential for authenticity. The tiny diver coming out of the sub's hatch was added for scale.

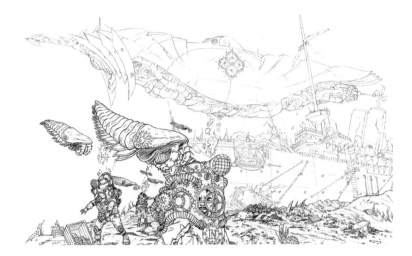

Beginning to ink, with dip pen and Rapidographs.

Inking the sunken ship. Note the rendering added on the hull, to give it a rusted look and more realism.

Final inks, after pencil lines have been erased. This is then scanned at 600 dpi (saved as a jpeg) and opened in Photoshop.

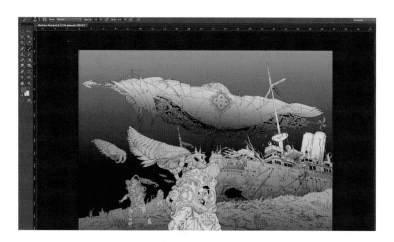

Beginning to color. First I made and stored a bunch of big selections, then started dropping in large areas of color with the edit > fill option and the gradient tool.

After darkening the sea, I started elaborating the sub with the brush tool and dodge/burn tool.

Adding lighting effects, and using the crop tool to trim the edges of the image.

Here I've loaded my previous selection for the sea floor and am now adding details there.

July 2155: On the South Polar Ice Plateau of Procyon B 2 (Part I)

This is the Oyster. Originally developed by the Narita-Lichtstrom Corporation for military purposes, these vehicles have been repurposed in small numbers for scientific research in extremely hazardous environments. The Oyster is versatile and maximally tough, with a five-inch-thick hull of magnesium-titanium alloy, and running off a miniaturized deuterium fusion shunt. It can function well in temperatures that range from zero degrees Kelvin to eight hundred degrees Fahrenheit. A fully stocked and well-maintained Oyster can comfortably sustain a crew of ten for up to two solar years, even in the most desolate environments. The Oyster pictured here is being examined by two of the so-called Old Men of the ice plateau.

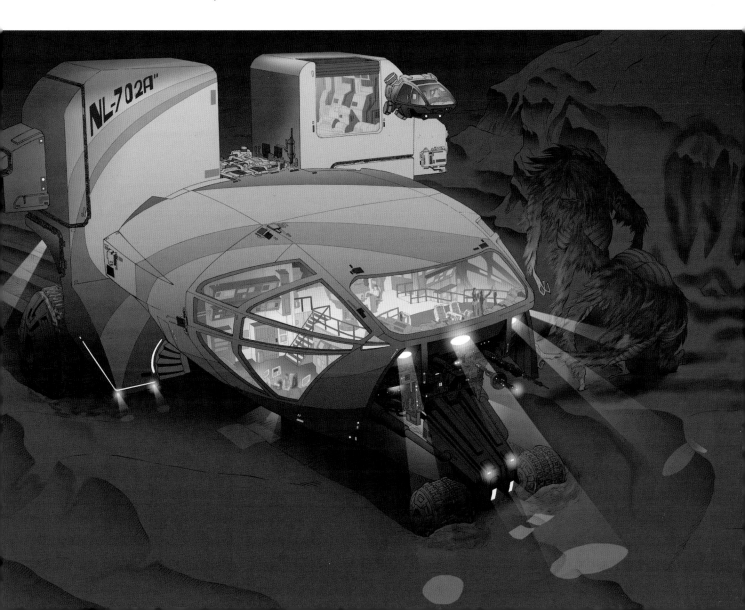

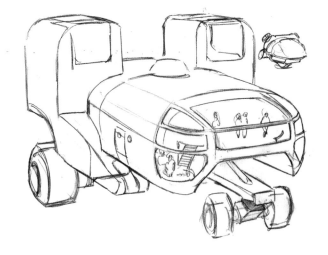

The initial sketch. I wanted to create a pleasing contrast between the vertical, squarish masses behind and the more rounded, horizontal mass up front.

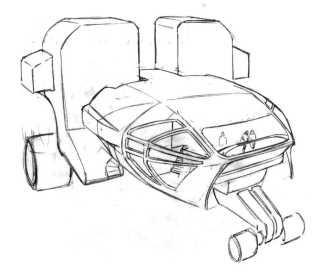

The second pass.

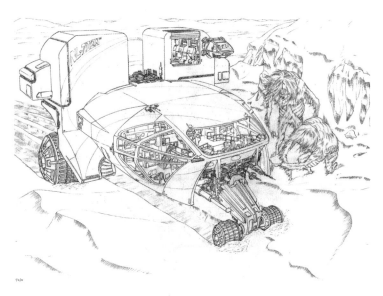

I created the final pencils on the basis of the second drawing using the light-box method. Working out the interior was time-consuming but great fun; I'd love to live in this.

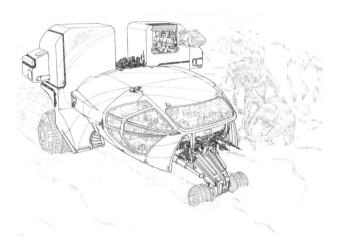

Working on the inks, with Rapidographs and various drafting tools (I relied heavily on the french curve for this).

Using dip pen and india ink to ink the giant aliens' fur.

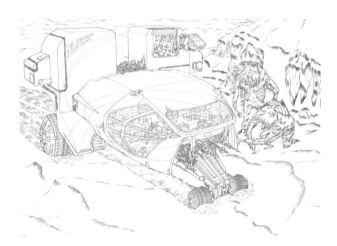

The final inks, which are then scanned at 600 dpi (saved as a jpeg) and opened in Photoshop.

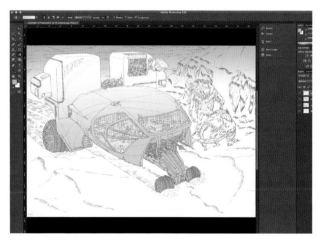

Starting to color. I wanted everything in this image to be cool except the vehicle's interior, which I wanted to radiate with warm colors.

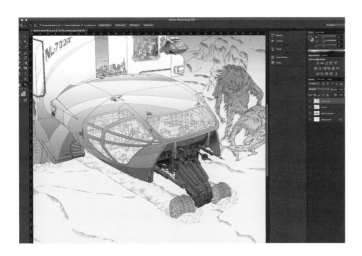

Working on details of various sections of the vehicle.

Adding detail to the vehicle's interior.

Adding lighting effects with the selection tool and the gradient tool on 25 percent opacity.

Loading my stored selection for the "Old Men" to work on them more.

July 2155: On the South Polar Ice Plateau of Procyon B 2 (Part II)

When it encounters obstacles it can't negotiate on the ground, the Oyster can make limited "hops." Here we see an Oyster hopping after dispatching a reconnaissance vehicle and research team, which it will rendezvous with later on.

Again, I try to balance form and function; the wheels do double duty as lift engines.

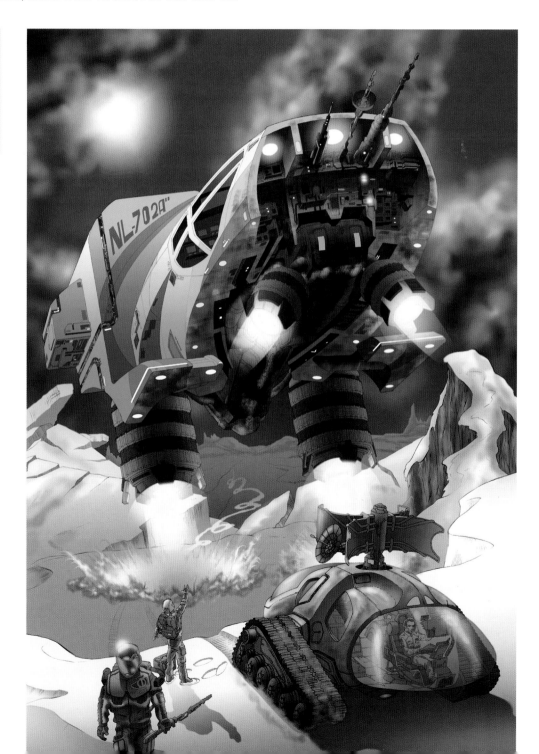

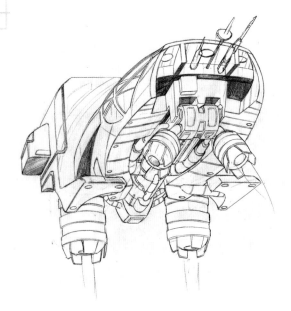

Here is my initial sketch of the Oyster taking off. It's always tricky rotating an irregularly shaped object, in your mind or on paper. It takes a lot of practice and a lot of erasing.

Various preliminary sketches of the mini snow vehicle in the foreground. I'm just playing with shapes, seeing if anything grabs me.

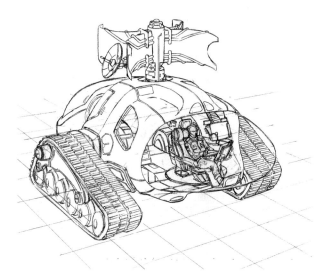

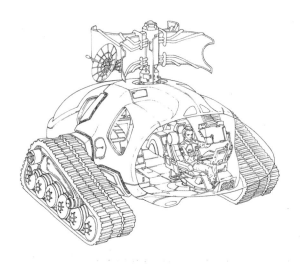

Pencils of the version that I ended up liking, with perspective lines. I used reference photos of battle tanks found online when doing the treads.

Inks of the mini snow vehicle, all done with Rapidographs and drafting tools.

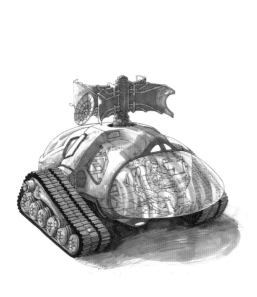

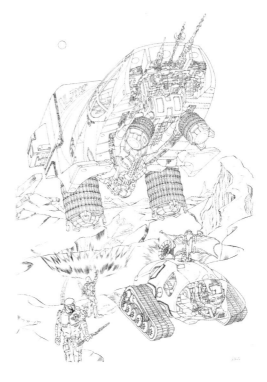

A color study of the mini snow vehicle, done with markers and white ink, over a photocopy of the final inks.

Here I've pasted a photocopy of the mini snow vehicle onto the pencils of the Oyster taking off.

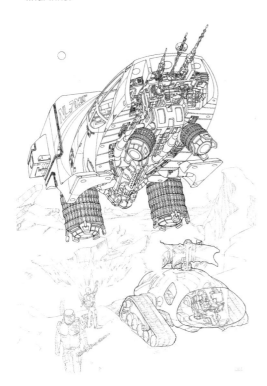

Inking the Oyster.

Final inks of the entire image, which is then scanned at 600 dpi (saved as a jpeg) and opened in Photoshop.

Starting to color. I'm dropping in masses of color with the edit > fill option and gradient tool.

Working on the undercarriage of the vehicle. You can see that I've made a very involved selection here, and am using image > adjustments > brightness/contrast to darken it.

Working on the mini snow vehicle. You can see that I didn't stick to that early marker version.

Adding detail to the figures. Notice that this guy ("foreground man") got his own layer. It's a good idea to give different elements their own layer so you can change them without affecting anything else. I often forget to do this.

The Present: An Airbase Somewhere in Surrey, England.

This is (allegedly) a photo of the Time Machine. Nothing is known about its origin, or the identities of the two pilots/drivers posing with it. What is (again, allegedly) known is that although it may move through time, it seems to be anchored to this particular spot on Earth's surface, appearing briefly at unpredictable intervals. The earliest known record of such an appearance dates from a 1721 deed of sale for an estate that then occupied this spot; it advises the new owner to be watchful for the occasional *"presence of a magickal carpet, or flying conveyance, reddish in colour, crown'd with a blue jewel or star, ridden by two blessed angels, which cometh and goeth as suddenly, for causes known but to God."*

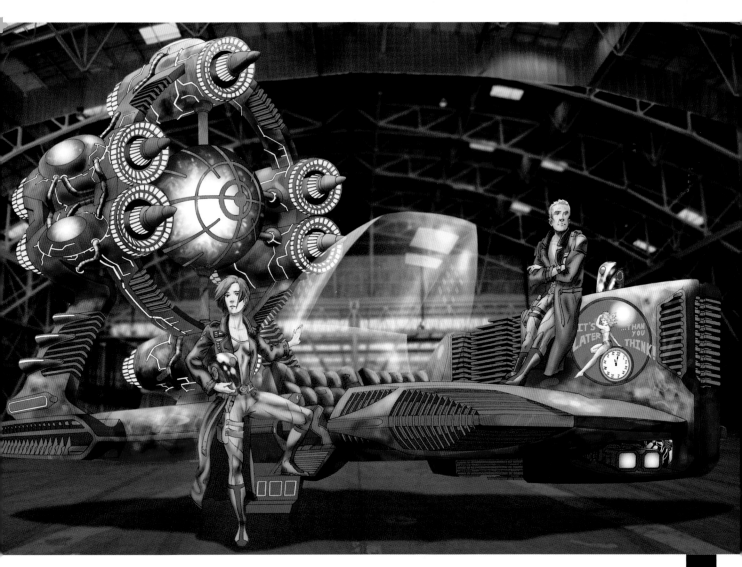

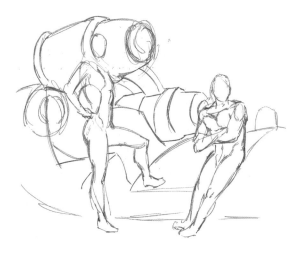

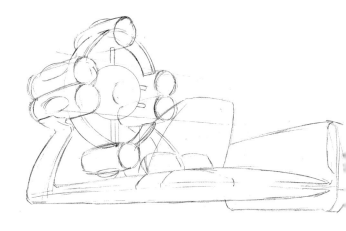

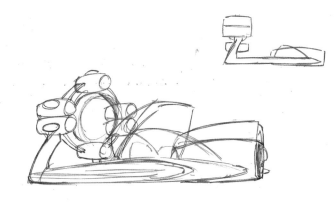

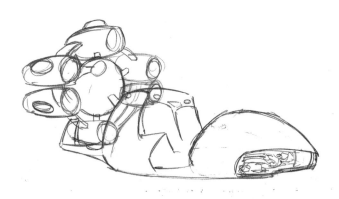

First sketch. The basic form of the engine survived into the final image.

Next sketch; getting closer.

A sketch figuring out the poses/attitudes of the two figures.

The first lines of what will become the final drawing.

There have been many time machines in science fiction—the TARDIS from Doctor Who, *the Guardian of Forever* from the original Star Trek *TV series, and "Doc" Brown's DeLorean from* Back to the Future, *to name only a few. The most famous was designed by Bill Ferrari for the 1960 movie of H. G. Wells's 1895 novella* The Time Machine. *I wanted mine to be evocative of that design, in that there's a cockpit with a big circular thing behind it. But I wanted it to look somewhat ambiguous; the hot-rod-red chassis suggests the 1960s, the nose art is definitely of the World War II era, and the engines seem to come from some undetermined future.*

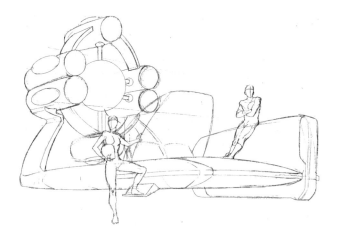

And the addition of the two figures.

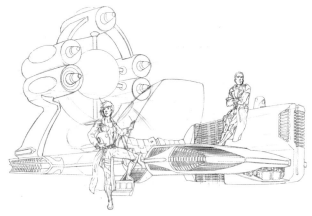

Pencils almost done. I wanted all that severe-looking grillwork to counterbalance the many rounded forms.

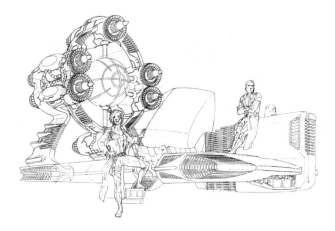

The final pencils.

The nose art was an afterthought. I looked at reference photos of actual World War II bomber nose art for guidance and authenticity.

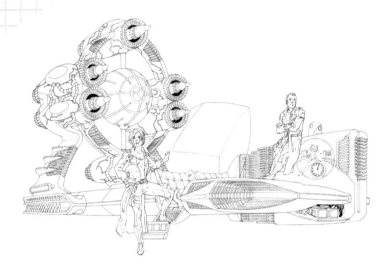

Final inks. I drew the nose art on a separate sheet, then pasted a reduced Xerox copy of it to the image.

I then scanned the final inks at 600 dpi (saved as a jpeg) and opened in Photoshop. Starting to drop in masses of color just to get a feel for where it's going.

Doing the engine detail was a complicated and time-consuming affair. You can see here a massive selection that I've made for the energy effect.

It looks good. Here I'm working on those grills—another big selection.

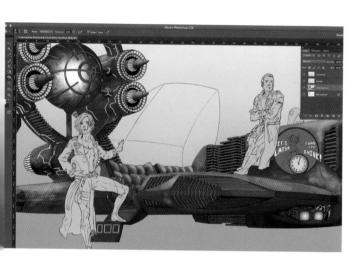

Working on the chair and nose art. The rendering on the red body was done with an array of brush tips in various modes (normal, soft light, color dodge); I'm just layering tones over one another, always with very low opacity.

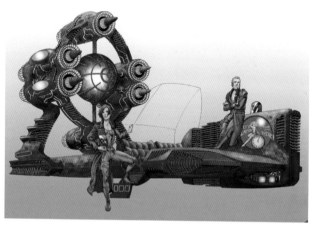

The machine and figures are finished. Originally I was going to leave the image like this, as if the machine were lost in some timeless void.

But it seemed wrong. The machine seemed to belong in a hangar (I guess the nose art just reminded me too much of airplanes). I downloaded this image (which seemed a fairly close match in terms of perspective) from istockphoto.com for about seven US dollars.

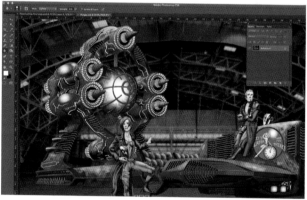

I merged the two images (there are plenty of YouTube tutorials telling how to do this). I then played with the brightness and hue of the hangar to make it work with the machine, and blurred it a little with the blur tool to add depth. Finally I added lighting effects to the cockpit shield and the shadow under the machine.

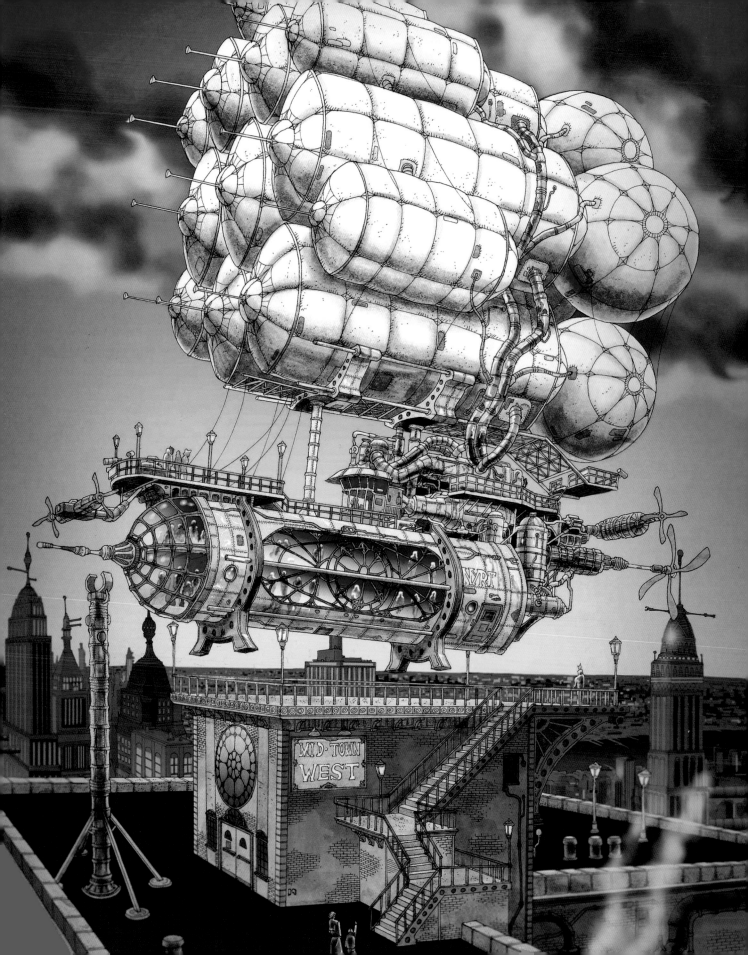

FLYING VEHICLES

From *A Trip to the Moon* (Star Film Company, 1902)—one of the most frequently reproduced images in pop culture history.

It is here, with spaceships and other flying vehicles, that utopian and dystopian science fiction begins to realize its true potential. The very first science fiction film, Georges Méliès's *A Trip to the Moon* (1902), documents the voyage of astronauts to the moon and their encounter with its inhabitants. With the realization that we can *fly*, nay that we can escape Earth's gravity and survive in deep space, an infinite narrative horizon opens up—but again, in good science fiction we are always concerned first and foremost with exploring *human* potentials and spiritual development. Is it our destiny to colonize the galaxy and beyond? And is it only there that we'll achieve moral and spiritual maturity? Will we even evolve there into something superhuman?

The Excelsior, the Enterprise, and Spacedock, from *Star Trek III: The Search for Spock* (Paramount Pictures, 1984).

Space travel has its dark potential as well. If we take real history as our guide, we can only wonder that the first spaceships haven't been warships. The final frontier offers as much scope for conquest and aggression as it does for exploration. And if we do build interstellar warships, will they be equipped to deal with alien opponents? Is it possible that human aggression is as nothing compared to that of whatever militarized alien counterparts are waiting for us out there?

The Hermes from *The Martian* (20th Century Fox, 2015), an astonishingly convincing vehicle of the near future.

Here, then, is the construction and launch of six of my own flying machines, at least one of which is dangerous indeed.

Klingon warship from *Star Trek: The Motion Picture* (Paramount Pictures, 1979).

OPPOSITE: A *steampunk airbus* (see page 167). An image from an alternate reality in which hydrogen-powered balloon travel really took off. Yes, intended, sorry.

April 2314: En Route to Alpha Centauri

This is a Sleipnir-class nuclear ramjet, a vehicle designed to house tens of thousands of people for the centuries-long voyage to our nearest celestial neighbor. The globe near the center is the ship's nuclear pile; it contains countless fusion charges. Periodically, a charge is jettisoned and detonated behind the two-mile-high blast shield, creating the propulsion that moves the ship. The nuclear pile is surrounded by a torus that collects escaping radiation and converts it into usable electricity for the ship's living section.

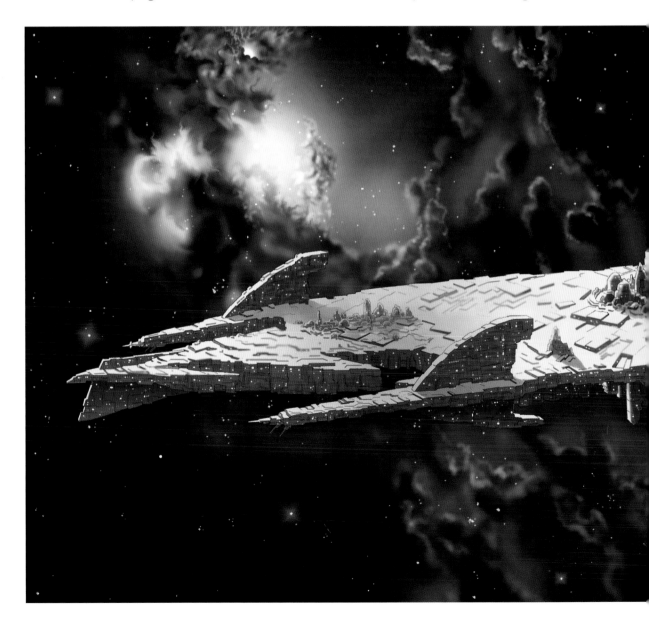

The astronomer Carl Sagan described a vessel of this kind in an episode of his Cosmos TV series, and I've always been fascinated by it. If memory serves, he called it a sort of "interstellar putt-putt boat." In point of fact, by our current technology it would take about three hundred thousand years to reach Alpha Centauri, four light-years away.

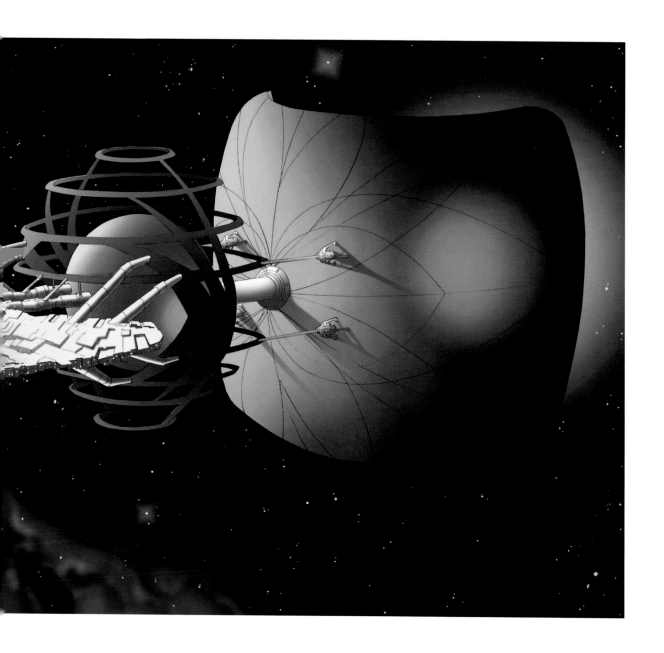

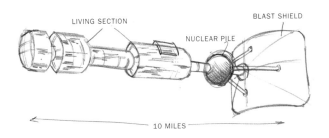

LIVING SECTION

NUCLEAR PILE

BLAST SHIELD

10 MILES

ABOVE AND LEFT: Three pencil roughs.

BELOW: The pencil rendering of the version I finally went with.

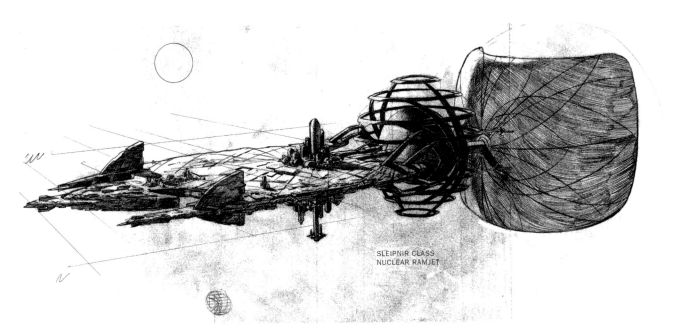

SLEIPNIR CLASS
NUCLEAR RAMJET

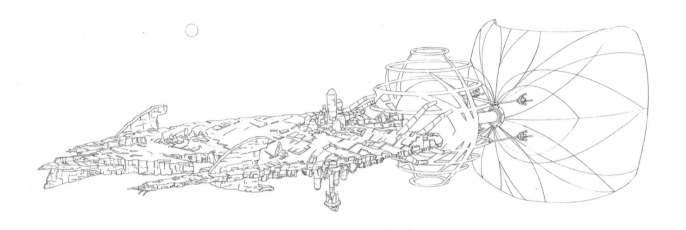

Final pencils, made with the light box and the pencil rendering at bottom on the opposite page.

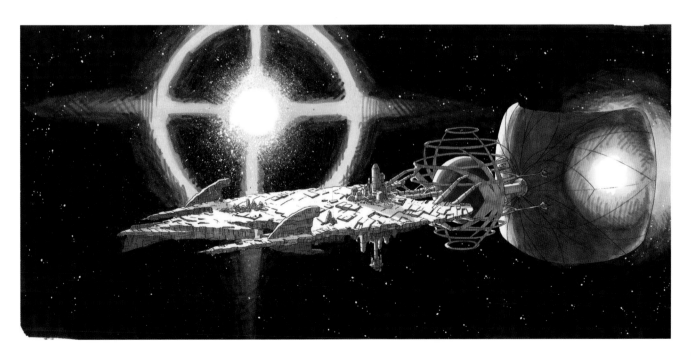

A color test done with markers and white ink, over a photocopy of the final pencils. I decided that the background starburst was pretty but overpowering, so I changed it later on.

For this piece I opted to skip the inking; the final pencils were scanned at 600 dpi (saved as a jpeg) and opened in Photoshop. Here I'm laying in masses of color and using a big, soft brush for the background effect.

Continuing to elaborate the background with a soft brush and circular gradient tool for the bright burst at center.

Working on ship details, with a complicated selection for the ship loaded.

Adding minute lighting details to the ship using a hard brush with a tiny tip and high opacity and the pencil tool.

February 2185: En Route from Earth to Ganymede

On February 6 two supply ships bound for the Amundsen Orbital Mining City over Ganymede encountered this object; the image was recorded by the second supply ship. The object was nicknamed the "Sunfish" by the captain of supply ship 1. It did not appear on sensors, and vanished moments after having been spotted, by propulsion means unknown. The size/distance ambiguity of space makes it impossible to estimate the object's size. No other such encounters have been recorded since.

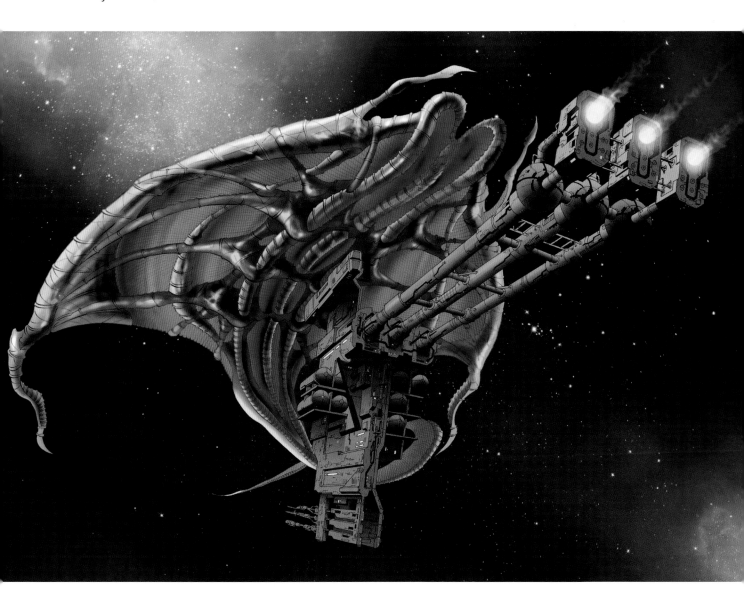

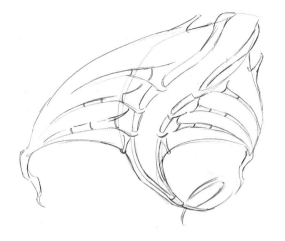

Here is a quick initial rough of the alien ship. I was going for a stingray effect, and looked at photos of stingrays found on the Internet.

Fleshing out the rough, adding harder, bonelike elements with a vaguely mechanical feel.

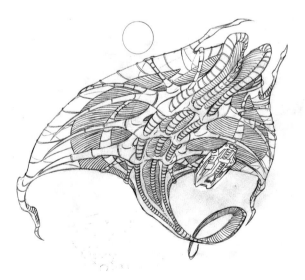

Here I've finished off the pencils of the alien ship and added the human ship as an afterthought, mainly to establish scale.

Yet again—is it alive, or is it a machine, or both? We can't say much at this point about what an encounter with real aliens would be like, except that it would be far stranger than anything sci-fi has given us yet. This image is all about contrasts; the warm alien ship is all form, the cool Earth ship is all function.

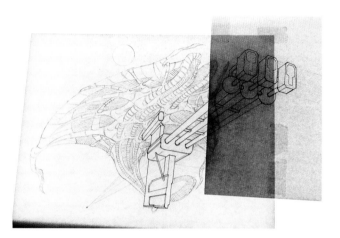

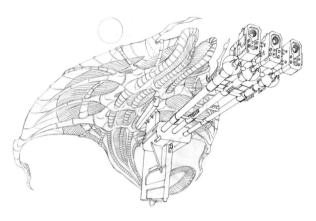

I decided to make the human ship bigger and more involved, primarily for the drama of its contrast with the organic alien ship. Here I'm using the light box and a separate sheet to work out the design and perspective.

The final rough, ready to be used as the basis for final pencils.

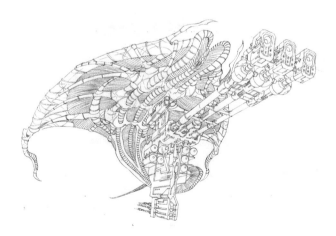

Final pencils.

Inking the human ship, all with Rapidographs.

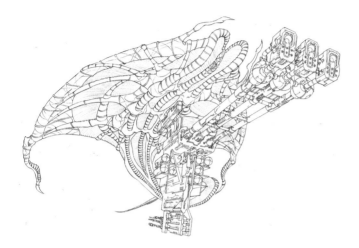

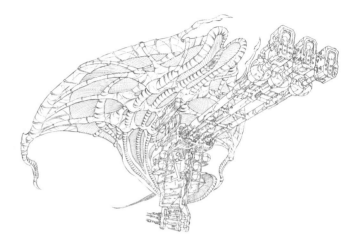

And inking the alien ship, all with dip pen and india ink.

Final inks, after erasing pencil marks. This is then scanned at 600 dpi (saved as a jpeg) and opened in Photoshop.

Starting to color, dropping in large masses. I wanted to establish the warm/cool contrast right away.

Elaborating details and shadows on the human ship, mainly with the gradient tool.

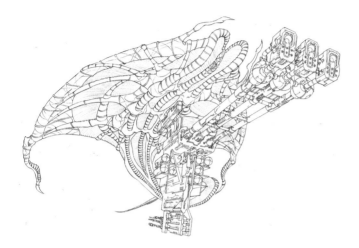 DEMO

And starting to work some color structure into the alien ship. This involves making and storing lots of selections.

Continuing to work on the alien ship.

Adding details to both ships. I used the dodge/burn tool quite a bit to give the alien ship that vaguely metallic shine.

I downloaded this image from istocksphoto.com for the background, for added realism and punch.

July 2401: Over Europa

Rebels from the cult of Cyberascension have seized a massive stockpile of water on the surface of Europa (at the height of crippling global droughts on Earth) and are holding it pending agreement to their demands for independence from Earth. Here we see Terran battleships attempting to get past an ancient missile platform the Cyberascendants have commandeered.

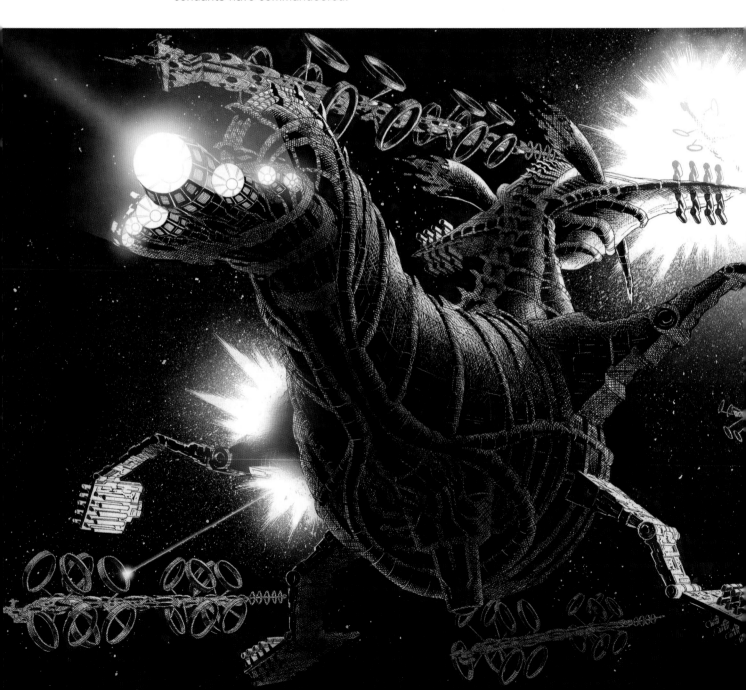

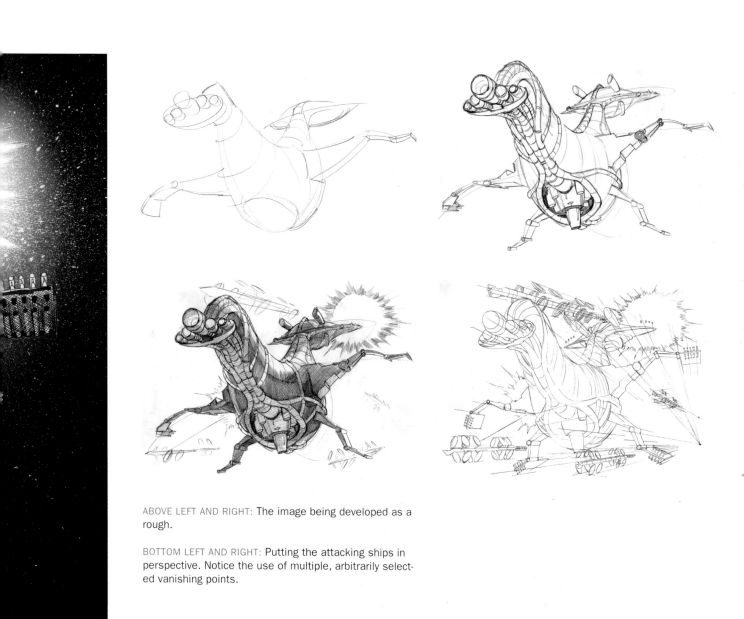

In this scene from a spacegoing war dystopia, I was mainly concerned with the contrast between two very different technologies going head-to-head—a grizzly bear versus a swarm of hornets—and once again I was aiming for sheer scale and grandeur.

ABOVE LEFT AND RIGHT: The image being developed as a rough.

BOTTOM LEFT AND RIGHT: Putting the attacking ships in perspective. Notice the use of multiple, arbitrarily selected vanishing points.

Elaborating the main ship. I was very much in Giger-esque biomechanical mode, going for the feel of a great, floundering sea creature.

Final pencils, ready for ink.

Inking the main ship, with both dip pen and Rapidograph.

Inking in the attacking ships, and the explosion bursts (with dip pen).

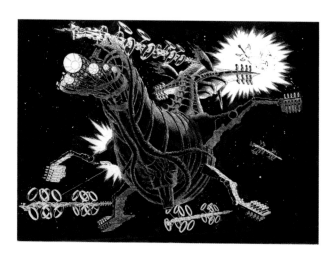

Spattering liquid frisket (masking fluid) on the space area—a technique for rendering stars. After the frisket dries, I lay black ink over it with a brush. After the ink dries . . .

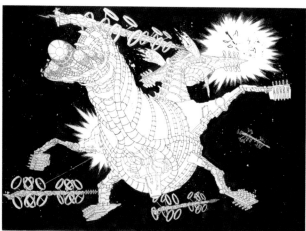

. . . I rub away the frisket and, voilà! Instant outer space.

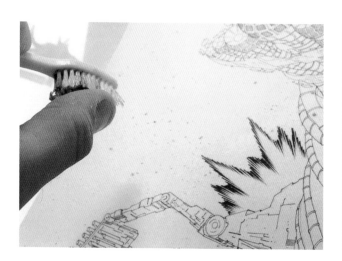

Next, I add cross-hatching to the body of the main ship.

Now to add white spatter for the explosions. First step: I apply masking film to the areas I don't want affected and, with a penknife, cut away the sections that I want to cover with white spatter.

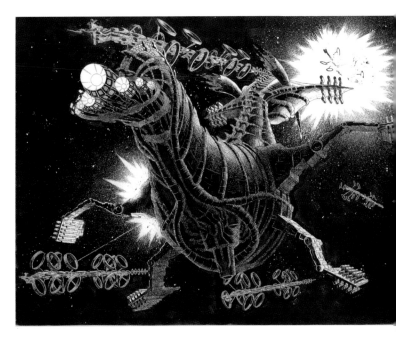

Spattering white ink with an old toothbrush.

Having done the spatter, I start to elaborate the cross-hatching with some white ink. The piece is basically done, but I want to pump it up more, so I scanned it at 600 dpi (saved as a jpeg) and opened it in Photoshop.

Here I've selected an area that will have some simple but effective lighting enhancements added. I used the round gradient tool with white color to amplify the explosion and laser beam.

And here I've selected an area so that I can use the gradient tool to enhance the energy from the ship's engines.

May 2220: The Command Center of a Kraken-class Uranium Transport, Entering Jovian Space

T his vessel is a workhorse of the interplanetary merchant marine. At two miles in length, it can carry a payload of more than 180 million metric tons of ore and other supplies on its runs between Earth, Mars, and Ganymede, which it is approaching in this image.

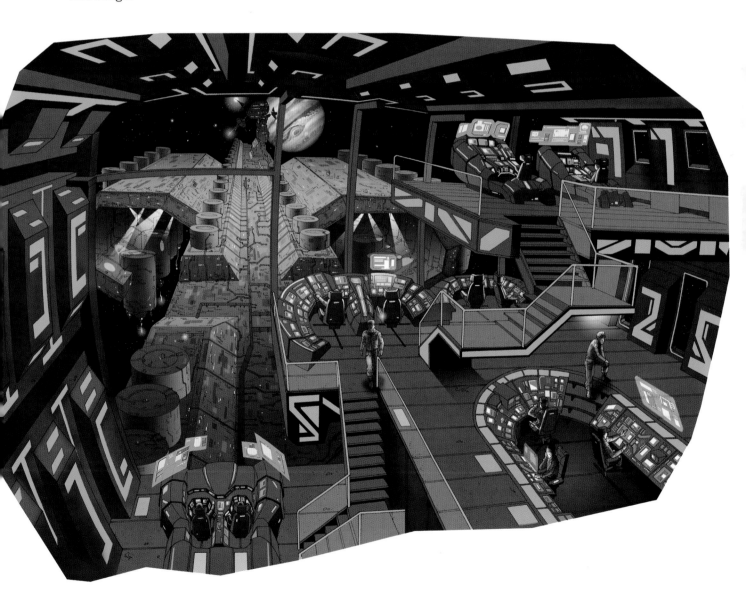

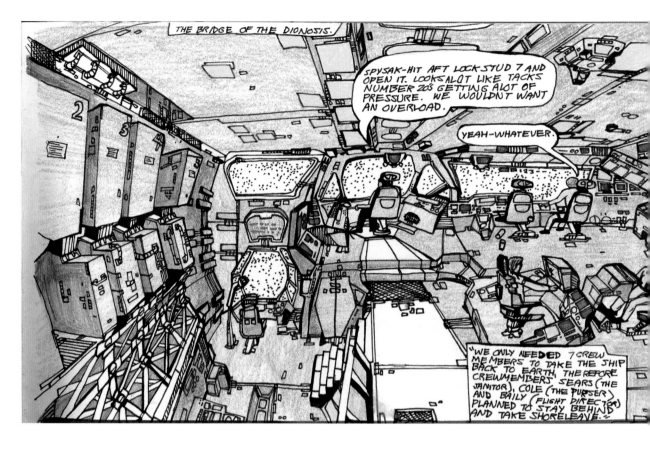

This piece was inspired by a starship bridge I drew in a comic story when I was fourteen years old.

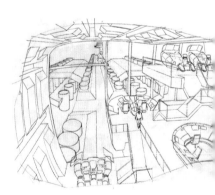

Laying out the exterior of the ship.

Completed rough.

Laying out the basic shape in accordance with that one vanishing point.

In this utopian image I was going for pure grandeur, establishing that ambience through perspective, a high vantage point, soothing cool colors, and the distant image of mighty Jupiter. Immense vehicles like this are a commonplace of contemporary science fiction. Whether or not they will one day be possible involves many "ifs"—if, for example, some form of artificial gravity is developed.

Doing final pencils with the rough and light box.

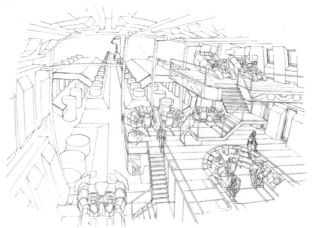

Final pencils, almost complete.

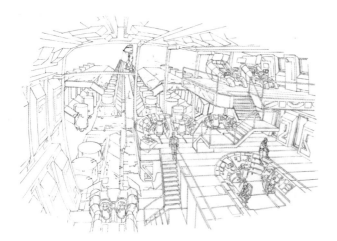

Final pencils complete.

Inking the bridge, all with Rapidograph.

Using white ink and dip pen to clean up little mistakes.

And the final inks, ready for color.

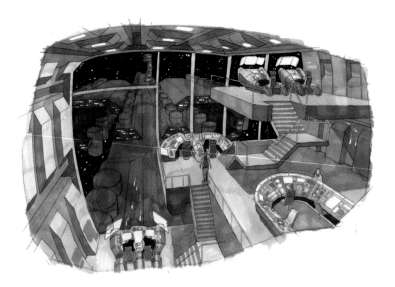

This is an early color test, done with markers and white ink over a photocopy of the final pencils. Originally I was seeing this all in shades of gray, like the bridge of a navy warship.

The final inks are then scanned at 600 dpi (saved as a jpeg) and opened in Photoshop. Starting to color, laying in big masses.

I decided to go darker with the color and make it look more like the bridge of a gigantic submarine; it just seemed to work better.

Working on little details of control panels.

I downloaded this image of Jupiter from istockphoto.com and merged it into the background for added punch and authenticity.

February 2094: International Space Station, Earth Orbit

A descendant of the current International Space Station (ISS). This all-purpose orbiting station is a disembarkation point for ships going to the moon or the newly established Martian colony, with multiple research facilities on board. At any given time it has a crew complement of more than one hundred people from many countries. The entire skin of the station collects solar energy. At right, a lunar shuttle is maneuvering to dock at the station.

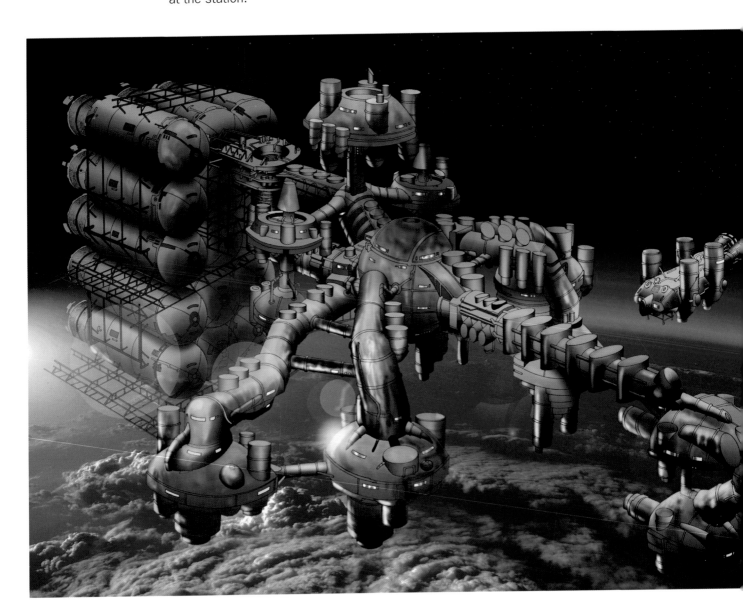

A preliminary sketch.

A second rough, obviously very close to the final version. Sometimes you nail it pretty quickly.

Final pencils in progress. I decided at this point to add that gigantic store of booster rockets at the back.

Here you see the rough taped to the back of a sheet of Bristol board and placed on the light box so I can do final pencils.

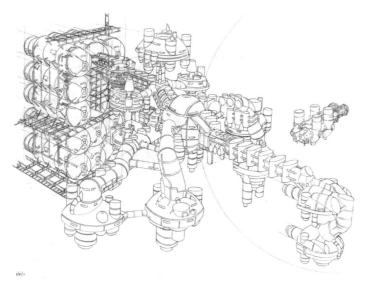

Continuing with final pencils.

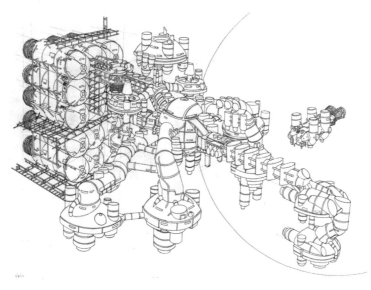

Final pencils, ready for ink.

And final inks, all done with Rapidograph.

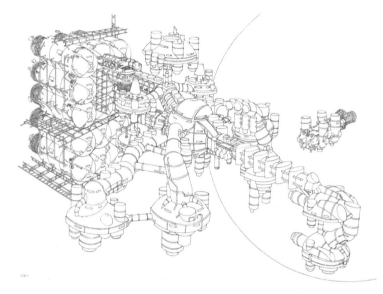

Final inks are then scanned at 600 dpi (saved as a jpeg) and opened in Photoshop. Starting to color.

Working on details of the station.

Giving the station a metallic sheen with the dodge/burn tool.

I downloaded this beautiful image from istockphoto.com to use for the background.

After merging the two images (plenty of YouTube tutorials on how to do this), I played with the hues, brightness, and color saturation by using image > adjustments > hue/saturation. I'm also using the blur tool to soften the outline of the station to make it fit better with the background image.

December 2016: New York City, 5:15 P.M.

A New York City public airbus departs from the Midtown West Station (Broadway at 70th Street, 120th floor) en route to lower Manhattan.

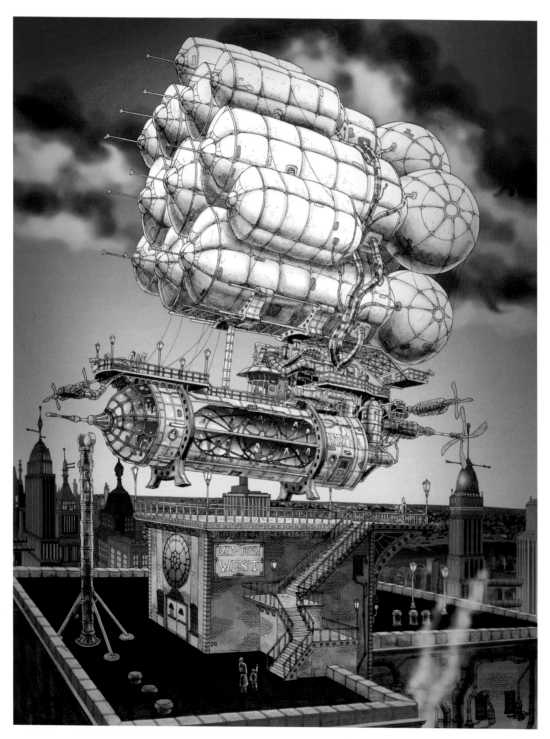

An image of the steampunk variety from an alternate present. There's no actual engineering rationale for the design of the engines/balloons; what counts is the overall impression of authenticity and realism. In reality, those balloons would not be able to lift that bus.

ABOVE LEFT: Initial rough of the bus. This was all done in one go—but notice that it's basically just a bunch of cylinders and spheres with a lot of detail added on top. I referenced numerous steampunk images online for inspiration, and pictures of Victorian-era steam engines for the engine. I thought about how the thing would steer; hence all the little propellers.

ABOVE RIGHT: Starting to do final pencils, using the light box and the rough.

RIGHT: Continuing with pencils; note the perspective lines. I didn't put down any vanishing points—I just "eyeballed" it, using my intuition and dead reckoning.

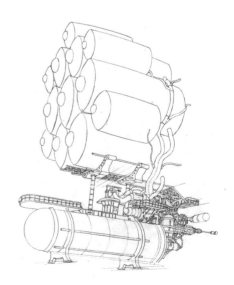

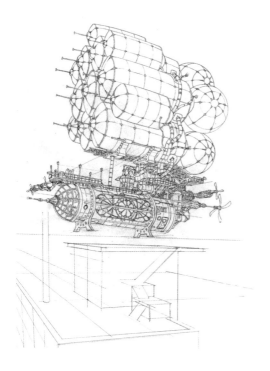

Starting to add the setting.

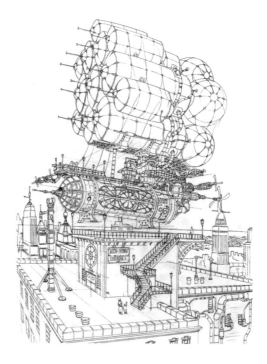

Final pencils.

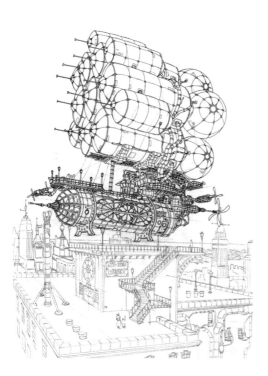

Starting to ink, all with Rapidographs.

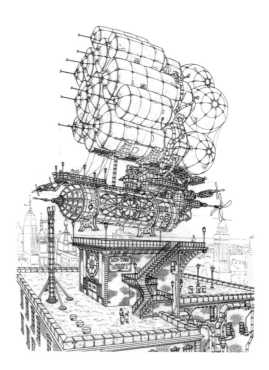

Inking the foreground building, adding lots of rendering for the brickwork that wasn't present in the pencils.

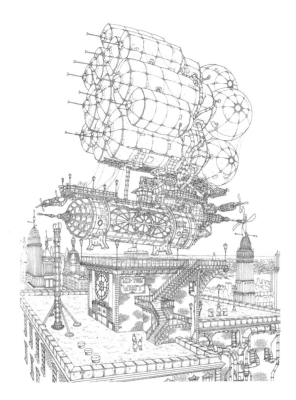

Final inks, after pencil lines have been removed. I used aerial shots of New York City for reference in doing the urban background.

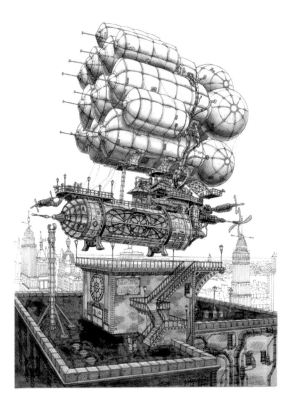

Most of this piece was colored with markers. Here I've started on the bus and foreground building. The marker colors were done directly on the final inks.

Continuing to build up color and detail, all with markers.

I then scanned the piece into Photoshop to color the rest. I laid in a nice gradient for the evening sky.

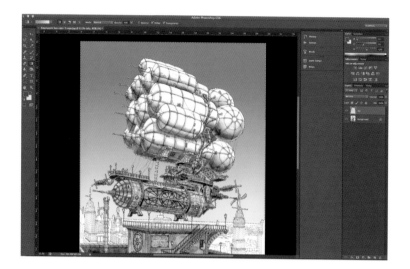

I rendered the clouds with pinks and grays using a big soft brush and the smudge tool. Here I've isolated the far background with the selection tool and am starting to work on it.

Working on details of the far background. It's basically just little cubes and rectangles of color, blurred out with the blur tool.

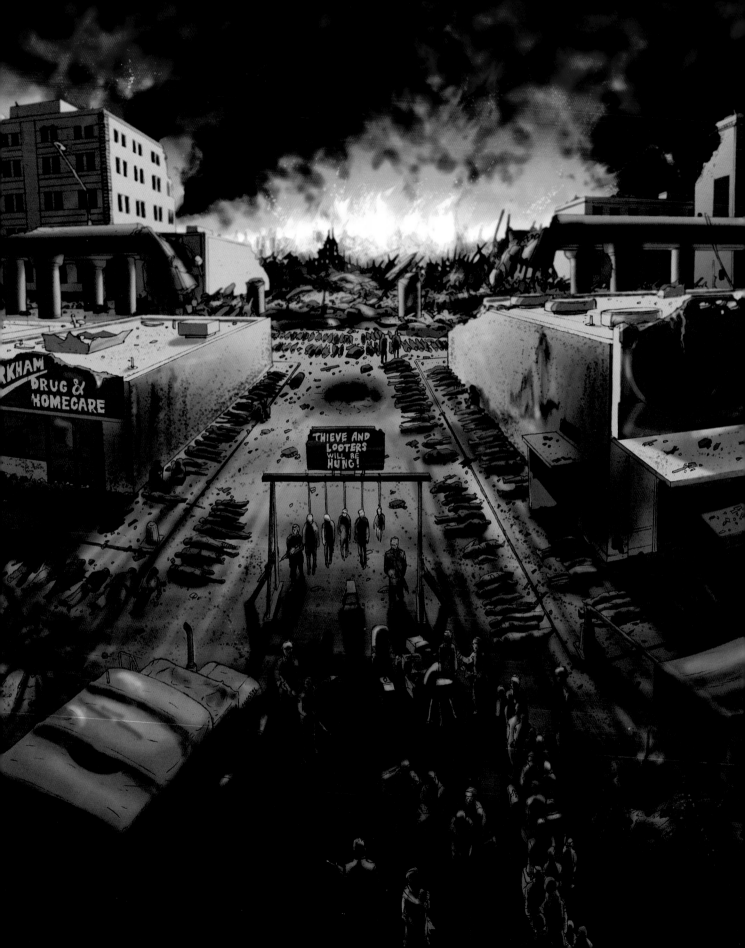

CITYSCAPES

The word *utopia* (literally, "no place") was first used by Sir Thomas More in his 1516 book *Utopia*. Funny, it's not really clear if More thought the rational society he described is a good thing, or what we might call *dys*topian. Planned societies—real, literary, or cinematic—are always Janus-faced, good and bad. Think of *Logan's Run*: you get to live a life of debauched abandon, but it ends at age thirty.

Before the 1950s, most portrayals of society's future were utopian; the great strides taken by science, combined with hubris about the spread of enlightened democracy, created a sense of certainty that the distant future would be a technological and political paradise. But with the horrors of World War II, the development of nuclear and biological weapons and artificial intelligence, and an increasingly crowded and disenfranchised planet, that sense has shriveled. More and more, the future is portrayed in sci-fi as a technological and political hellscape. As our collective fears and tensions grow, so do our dystopian visions. But a grim diagnosis of the future of humanity equals a powerful demand that we change our ways in the present. That's what science fiction is really about.

And so we end with representations of several sweeping thought experiments, some sweet dreams, some nightmares.

OPPOSITE: A moral dystopia: the aftermath of a nuclear war (see page 196). The worst of all the worst-case scenarios.

A cityscape from Fritz Lang's revolutionary film *Metropolis* (Universum Film AG/ UFA, 1927).

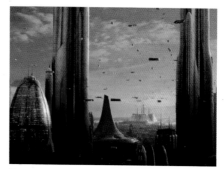

The planet Coruscant from *Star Wars: Episode III*, Revenge of the Sith (Lucasfilm Ltd./20th Century Fox, 2005).

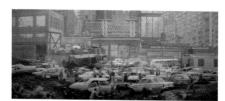

Manhattan in 2022—a crowded, toxic hellscape. From the immortal *Soylent Green* (Metro-Goldwyn-Mayer, 1973).

DEMO

Welcome to the World of the Year TWO-THOU-SAND-SAND-SAND-SAND!!!!

The world of tomorrow has it all, Mr. and Mrs. Consumer! Dreading that rush-hour traffic? Fly to work with your personal jetpack! Left the toaster on? Telephone your robot butler and he'll turn it off. Better yet, step into your personal time portal, zip back an hour, and turn it off yourself! Most incredible of all: a COLOR television in every single home!

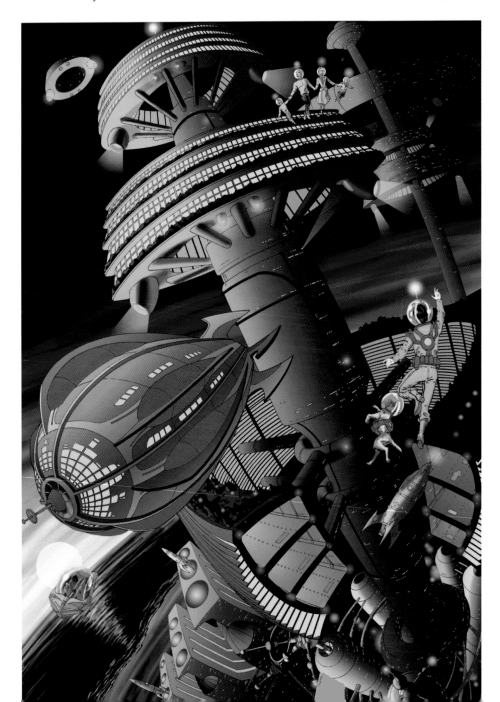

This is what the future used to look like; you could call it the retro-utopia. I referenced a lot of vintage sci-fi art for this piece, along with my fond memories of The Jetsons *animated* TV series, which originated in 1962. In the 1950s version of 2000, there were supposed to be flying cars, robot servants, and jetpacks. As of 2016, we do have Twitter, cellphones, and microwavable bacon. But still we have no commercially available jetpacks, and no robots that can make an omelette without burning the house down; by and large, most attempts to foretell the future in sci-fi are crazily off the mark. However, the point of good sci-fi is to say something about the current human condition; if you can do that, your mistakes about the future will just be by the way.

Initial rough. I was pressed for time on this one, so I just ran with what I had here.

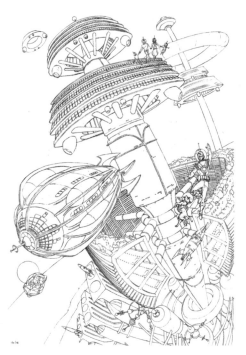

Final pencils, made with the rough and light box.

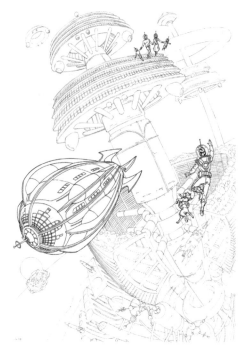

Starting to ink; the figures are done with dip pen and india ink.

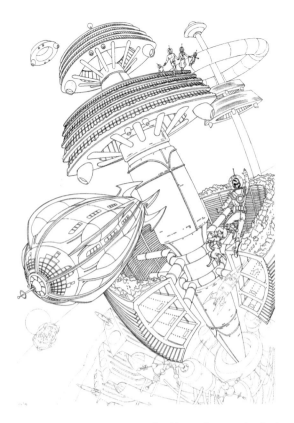

Continuing to ink, with Rapidographs now. I relied a lot on the french curve for all those curved lines.

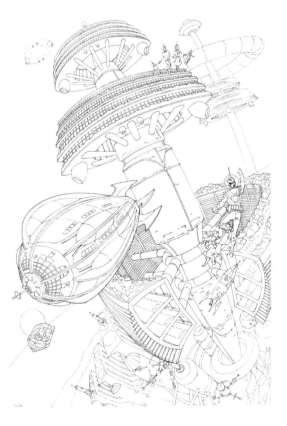

Almost done with inking; only the far background remains.

Final inks, after pencil lines have been erased.

Starting to work on a color
test, done with markers
over a photocopy of the final
inks.

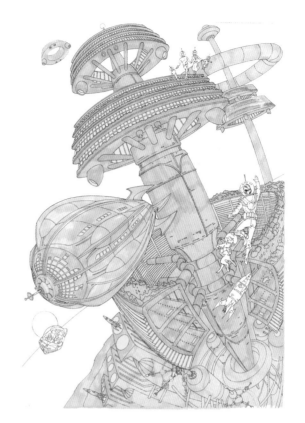

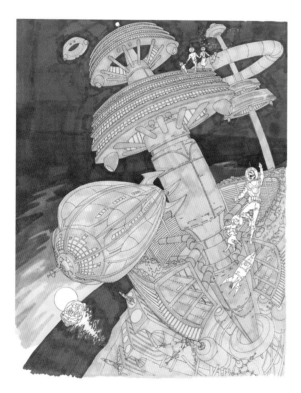

Marker color test,
part two.

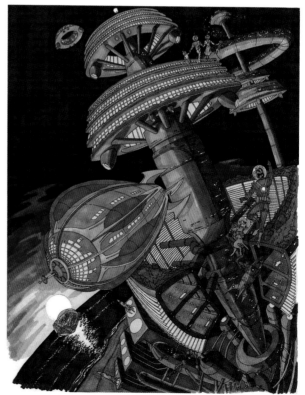

Final color test.

I then scan the final inks at 600 dpi (saved as a jpeg) and open in Photoshop. Here I'm using the marker color test I did earlier as a guide for laying in initial masses of color.

Here you can see all the selections I've made and stored for working on this piece. Time-consuming, yes. But things go much more quickly and easily at the end if you do this.

Using the dodge/burn tool and small soft brush to render one of the background vehicles.

Working on little details of the background characters.

2100: Shenzhen, China

Earth's population is in excess of fifteen billion people. China has at this point twenty-three cities with more than twenty million people; Shenzhen has a population of twenty-four million. Here we see tenement dwellers sixty stories up looking on as a

rooftop shantytown goes up in flames, a heartbreakingly regular occurrence. Even if firefighting resources were available, every ounce of potable water is needed for drinking. All that can be done is to let the fire burn itself out and hope it doesn't spread.

This is a scene from what could be called "the population dystopia"— the Malthusian catastrophe many think we are actually heading toward. The greatest population dystopia in all of science fiction was presented in the chilling 1973 film Soylent Green.

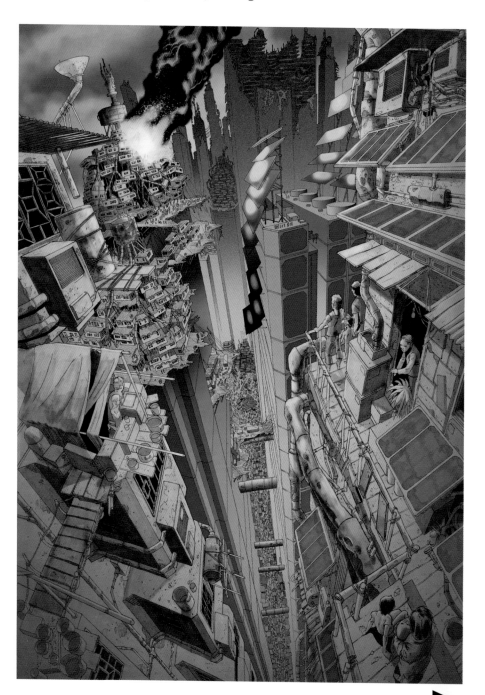

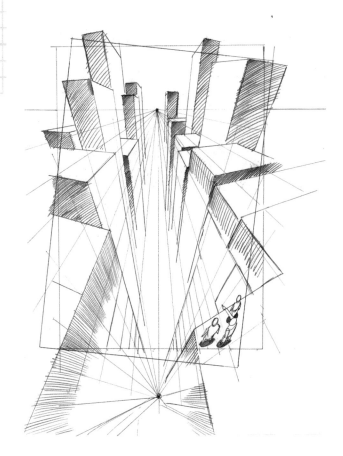

The only rough I did for this piece. I was mainly concerned about nailing the perspective to create a vertiginous instability. The off-kilter box shows how I decided to orient the final image.

I drew this perspective grid on a separate sheet, taped it beneath the piece of Bristol board on which I created the final work, and put both on the light box.

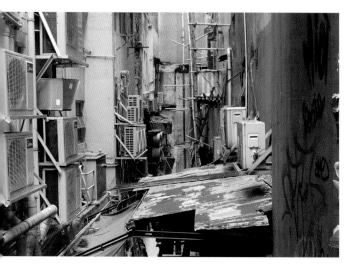

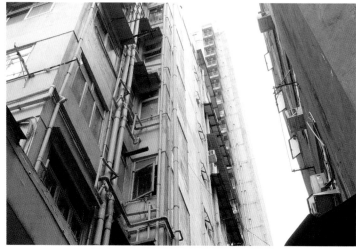

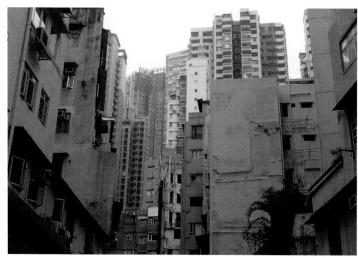

I took these photos in Hong Kong and referenced all of them in creating this piece.

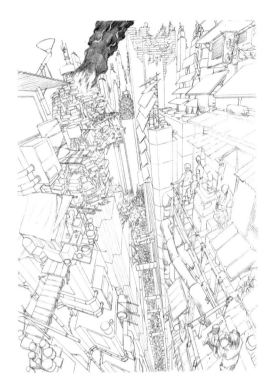

Final pencils.

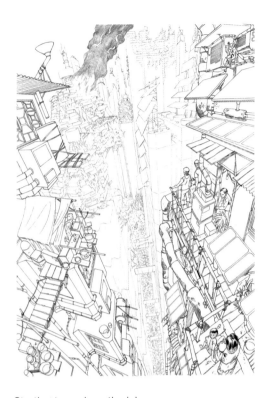

Starting to work on the inks.

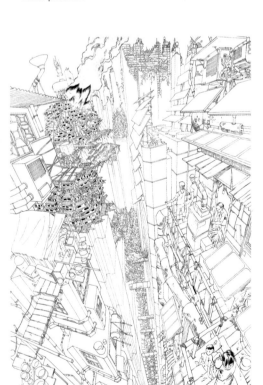

Continuing with the inks.

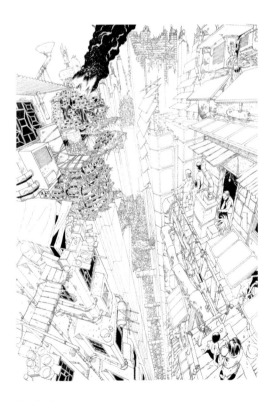

Final inks.

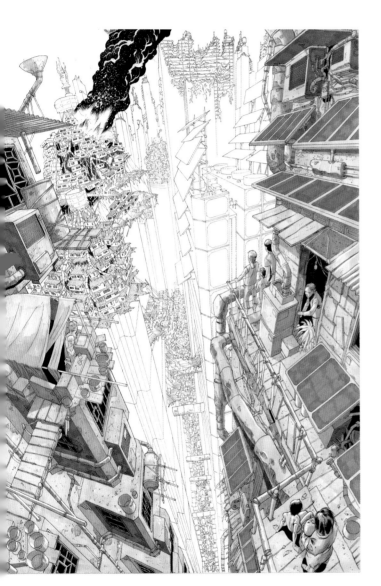

Adding more color in Photoshop. I wanted that fire to be the brightest thing in the picture.

Starting to color; I worked on the foreground elements with gray markers, directly onto the final inks. I then scan the image at 600 dpi (saved as a jpeg) and open in Photoshop.

Elaborating the background buildings. Finally I tinted the entire image with grayish green to pull it together and give the atmosphere a poisonous look.

December 2150: Hong Kong

Hong Kong Harbor has long since been filled in and built over; the tubular structures receding toward Hong Kong proper are where it used to be. Harbortown is a cauldron of every vice and crime conceivable, while the city itself is an enclave of the superwealthy.

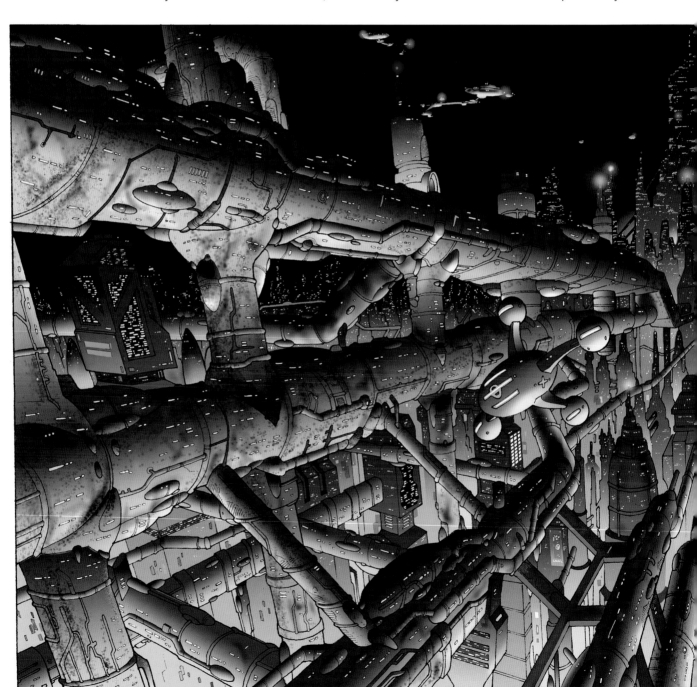

This scene came from contemplating the growing division of the world into the superrich and the desperately poor, and it has utopian and dystopian elements. I sought to reinforce this distinction by the use of predominantly horizontal lines in Harbortown and vertical lines in Hong Kong, and by giving the two areas different color schemes.

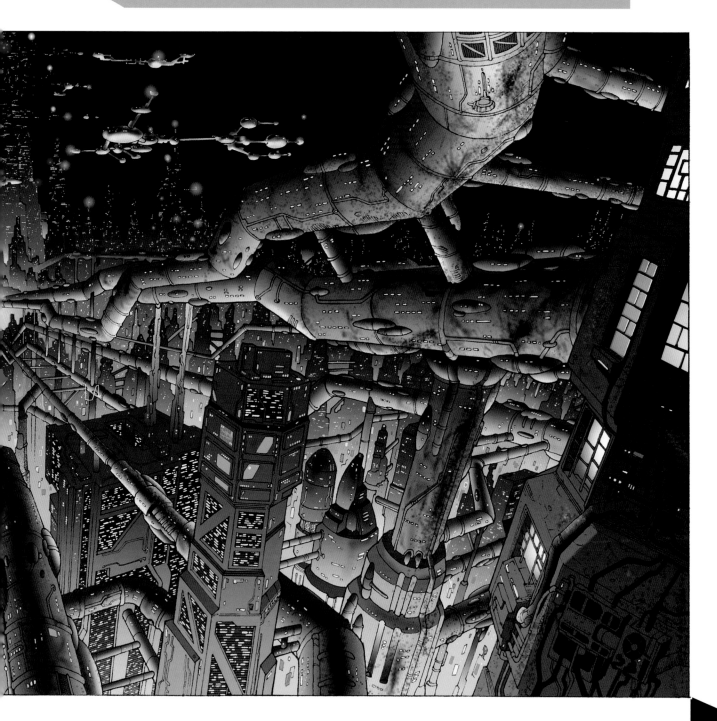

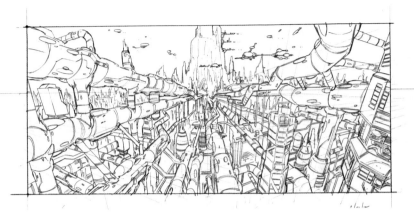

ABOVE: Initial rough, which is about six inches wide. There are three vanishing points visible. I just used my intuition for the fourth one, far down below.

ABOVE: Starting the final pencils. I used the light box and an enlargement of the rough.

ABOVE: Doing the pencils with the light box. The final pencil image is about two feet wide. I have an enlarged photocopy above to glance at as I work.

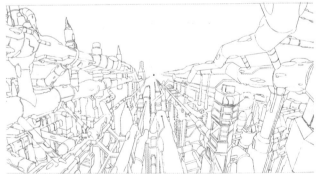

ABOVE: Continuing with final pencils.

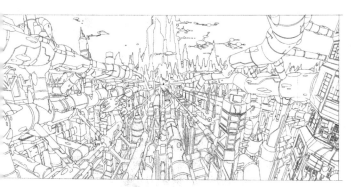

Final pencils, completed.

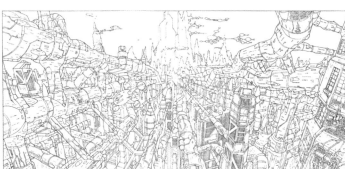

Final inks, all done with Rapidographs. Lots of detail added at this stage.

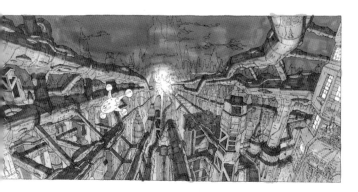

Beginning to do a color test with markers, over a photocopy of the final inks.

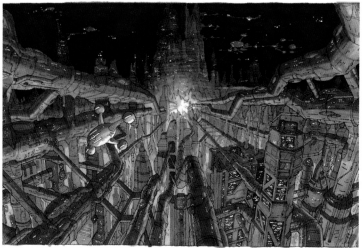

Final color test, done with markers and white ink.

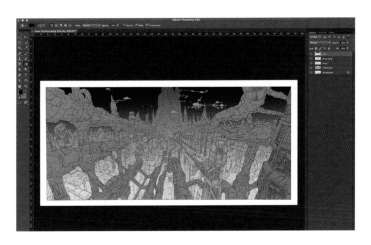

The final inks are then scanned at 600 dpi (saved as a jpeg) and opened in Photoshop. Here I'm laying in masses of color.

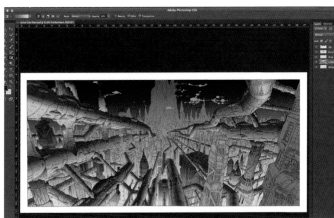

Putting in lighting transitions on the Harbortown pipes using the gradient tool.

Here I'm putting in rustlike texture effects on the pipes using the brush in one of its airbrush modes. You can get all kinds of textures with the brush tool; you just have to experiment with it to see what suits.

Putting in final little details on the buildings using the pencil tool. This takes a lot of time, but the payoff is worth it.

August 2190: The Lower Stratosphere, Twelve Miles Up

The amount of carbon dioxide in Earth's atmosphere is at this point six times what it was in preindustrial times. Earth's mean surface temperature is seventy degrees Fahrenheit; temperatures in the densely populated equatorial zones of Asia, Africa, and the Americas have monthslong heat waves of 140 degrees Fahrenheit or more. Heat and chaotic weather are causing massive displacements of humanity. Here, nanomachines are in the process of building/encircling Earth with this high-altitude international super-city, far beyond the accelerating heat.

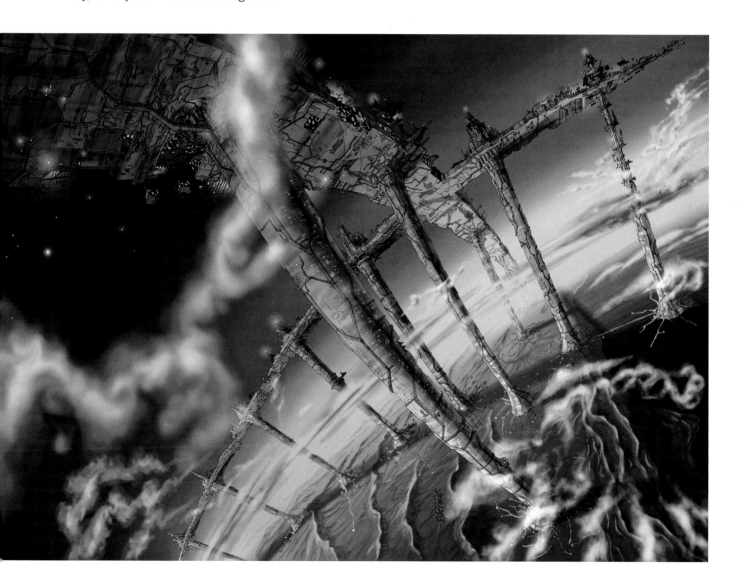

Floating/flying utopias are a recurring motif in sci-fi (think of Cloud City from Star Wars: Episode V, The Empire Strikes Back or Stratos from the original Star Trek TV series (in the episode "The Cloud Minders"). They are always images of sheer audacity—the triumph of human engineering over gravity itself. This image is only as insane to us as an image of New York City circa 2016 would have appeared to a New Yorker of 1816.

Initial rough.

Final rough.

Starting the final pencils.

Continuing the final pencils.

Final pencils, completed.

Starting to ink with Rapidographs.

All inked except Earth's surface.

Final inks, completed. These are then scanned at 600 dpi (saved as a jpeg) and opened in Photoshop.

Laying in masses of color with the gradient tool. Here I have a selection for the sky loaded.

Putting in some simple lighting indications on the ground, using a small soft brush with low opacity.

Putting in lighting transitions on the city, using a small hard brush in soft light mode. I constantly switch back and forth between different brush modes when doing this (mainly soft light, multiply, color dodge, and normal).

Here I'm working on the clouds with a soft brush. I have on screen a photo found online for reference.

August 2190: Somewhere in the Indian Ocean

Here we see the stratospheric supercity being built from closer to ground level. The vaguely organic-looking flying vehicles are actually composed of multitudinous self-organizing nanomachines, as is the growing city itself.

If Earth's atmosphere were considerably denser and hotter than it is now, the horizon might appear higher and more curved (standing on Venus would seem like standing in a giant bowl). I sought to convey something of that distortion in this image.

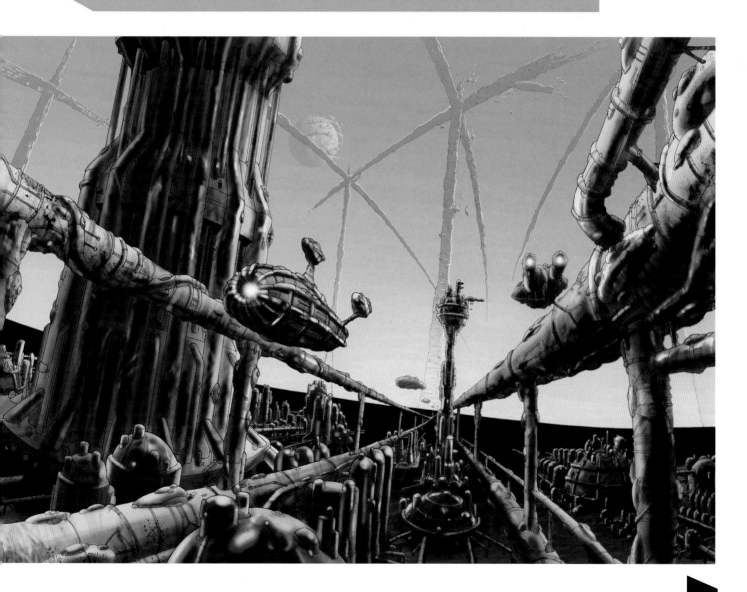

Initial rough.

Final pencils.

Working on the inks.

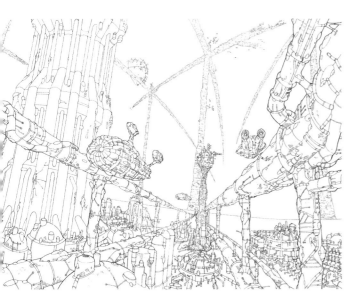

Final inks, after erasing pencil lines. Note how line weights diminish with distance. This is then scanned at 600 dpi (saved as a jpeg) and opened in Photoshop.

Laying in masses of color, using the gradient and edit > fill tools.

Bringing out lighting and texture effects on the pipes using the dodge/burn tool with soft tip and medium exposure.

Working on the ocean; I used a small hard brush with multiple opacities and colors, swiping back and forth, and then blurred it with the blur tool.

December 24, 1984: Pittsburgh, Pennsylvania

Two weeks have passed since the nuclear war; the scene is much the same everywhere in the Northern Hemisphere. There are no hospital or public facilities of any kind, and money is worthless—the only thing of value is trustworthy food, of which there is very little, and potable water, of which there is less. A firestorm continues to rage where downtown used to be. In another two weeks, the rate of deaths from fallout will peak.

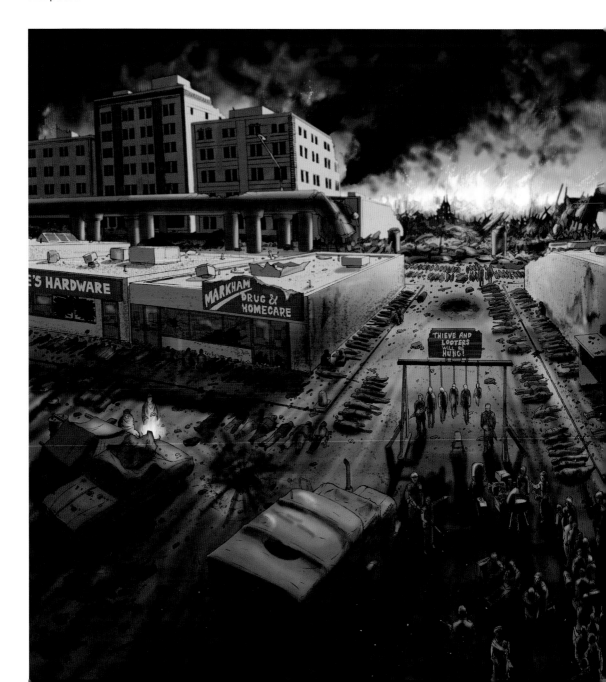

Postapocalyptic dystopias are a commonplace in science fiction. This is probably about what it would really look like after a nuclear war. I call this a "moral dystopia"—a situation without the hope of comfort or the comfort of hope, in which the possibility of right action has itself been destroyed, in which the living envy the dead (George Orwell's 1984, published in 1949, is another famous moral dystopia). We've narrowly avoided this dystopia a number of times, and continue to do so on a daily basis. This is the worst thing I can imagine.

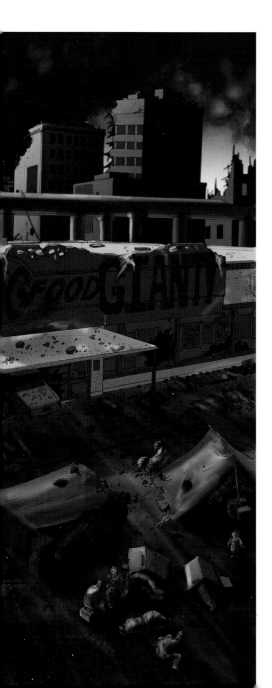

Initial rough, just the bare bones of an idea.

Adding details and shadows to the rough.

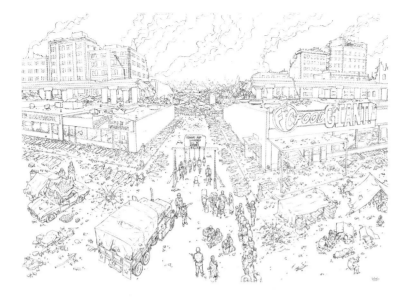

Final pencils, based on the rough.

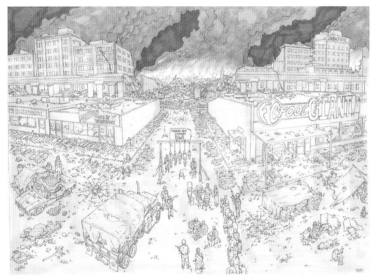

Starting to do a marker color test, over a photocopy of the final pencils.

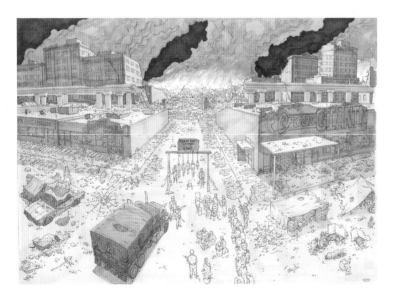

Continuing to work on the color test. For this piece I opted to skip inking and went straight to digital coloring.

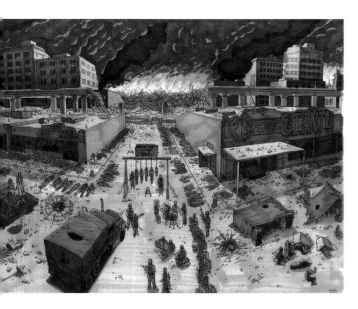

I scanned the final pencils at 600 dpi (saved as a jpeg) and opened them in Photoshop. The marker color test guided the digital coloring. Final color test, after I reduced brightness in Photoshop.

Loading a premade selection while laying in initial masses of color.

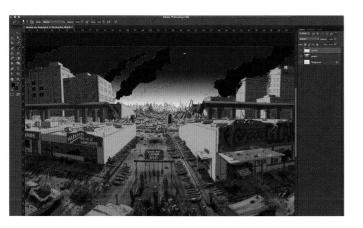

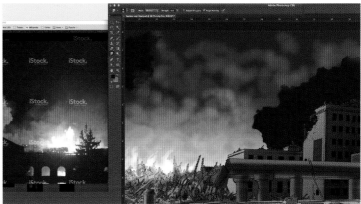

About halfway done. I'm laying in an initial color gradient for the far background firestorm using the gradient tool and a premade background selection.

Here I'm using a photo found online as a visual guide for doing the firestorm. I'm using the smudge tool to render the smoke and flames (it's also very useful in rendering clouds).

Spring 7112 (Gregorian): Earth, Capital of the Galactic Confederation

Warp drive has long since been developed, enabling man to spread far beyond our nearest stellar neighbors. Humanity numbers in the hundreds of trillions, but space and resources exist for all—in fact, for many trillions more, since there are now no known limits to expansion and colonization. Plans are under way for intergalactic travel. Peace reigns everywhere.

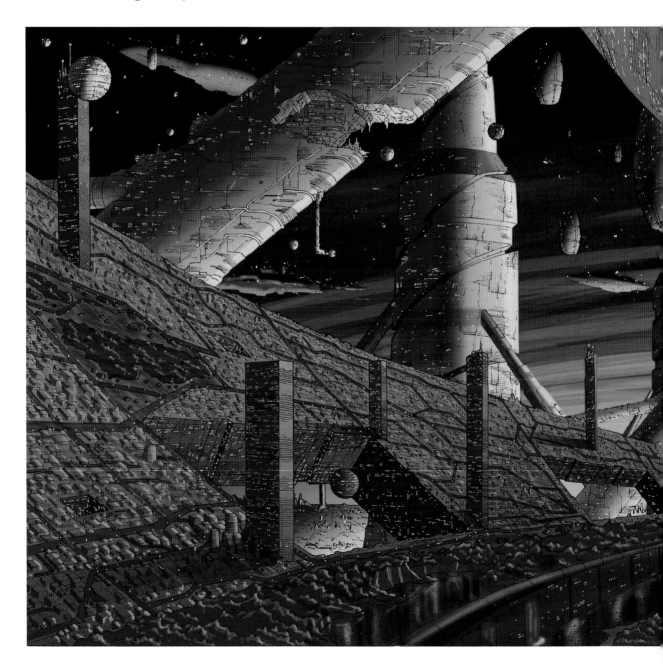

This is the moral utopia, the ultimate utopia, the opposite number of the nuclear war scenario. It is the situation in which mankind's capacities and aspirations are fully realized. The scenario has been sketched a number of times in sci-fi literature (e.g., Isaac Asimov's *Foundation*) and film (the planet Coruscant in the *Star Wars* prequels). Something very like this is, I think, the most we as a species can hope for.

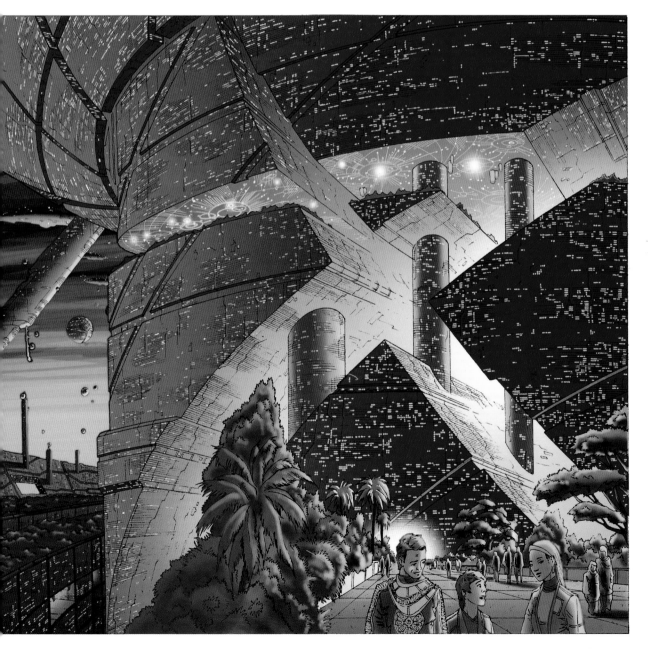

Start of the initial rough—about six inches wide.

Continuing on the initial rough.

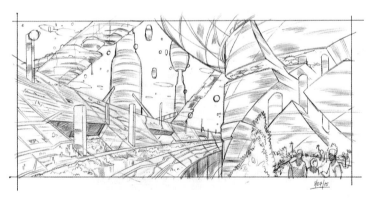

Done with the initial rough.

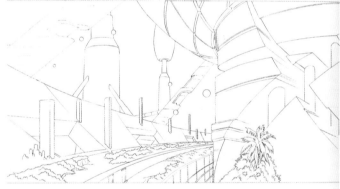

Starting on final pencils, with an enlarged photo-copy of the rough and my light box.

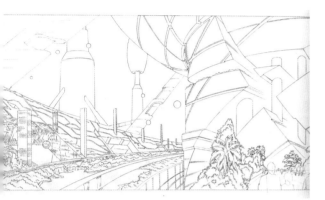

Continuing with final pencils.

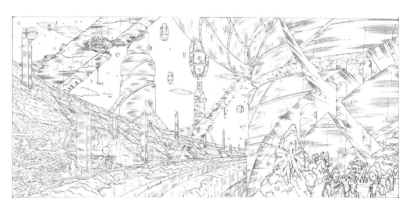

The final pencils.

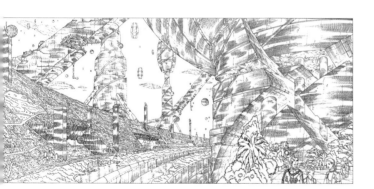

And the final inks—all done with Rapidographs, except for the people and trees at lower right (done with dip pen and india ink).

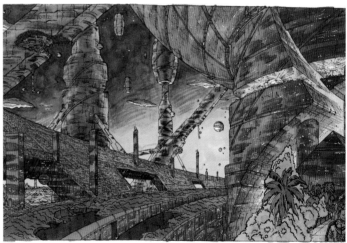

Color test done with markers, over a photocopy of the final inks. I'm going all out for warmth, balance, and beauty.

The final inks are then opened in Photoshop. Here I'm laying in masses of color, using the gradient and edit > fill tools.

Working on lighting effects of the woods/lake part of the city. I added highlights with a small soft brush and yellow color.

Rendering the surface of the main tower. I isolated the downward planes with the selection tool and then just adjusted the brightness downward using image > adjustments > brightness/contrast.

Adding final fine details with the pencil tool; it's very time-consuming, but a real Zen activity once you get into it.

afterword
TIME TO GET ON WITH IT.

On many occasions I've heard (or read) other illustrators say words to the following effect: "Nothing gives me greater pleasure than the ability to put on paper what's in my head."

I cannot relate to this.

Usually, there's nothing much in my head until after I see it on paper. I might have a sort of verbal description floating around in there ("an Earth ship encountering some kind of noodly, biomechanical alien ship . . . "). But there simply is no blazing Technicolor light show in my head screaming to be realized on paper. I have to start drawing, and usually it's with the sinking feeling that this time it isn't going to go anywhere. Usually I'm not sure if a drawing is actually going to succeed until I'm about *one hour* from completing it. Most of the pieces in this book took about four or five days each.

To be a professional illustrator, you have to have a "time to get on with it" attitude. You can wait for inspiration, but your deadline will not. If you're already a professional illustrator, this means mastering, organizing, and taking care of your art supplies, getting your reference material in order, budgeting time to work, and then working (and not procrastinating), whether you feel like it or not. If you're an *aspiring* illustrator, it means developing professional habits (all the ones I just said) before you actually become a professional. Set yourself assignments ("this month I'm gonna finally nail drawing the human head from memory") and then sit there and do it, whether you feel like it or not. Inspiration doesn't factor into the equation. *Retrospectively* I might suspect that one of my drawings was sort of inspired. But when I'm in the process of actually doing it, it's usually more like pulling teeth—or better yet, like sifting through endless pans of sand,

206

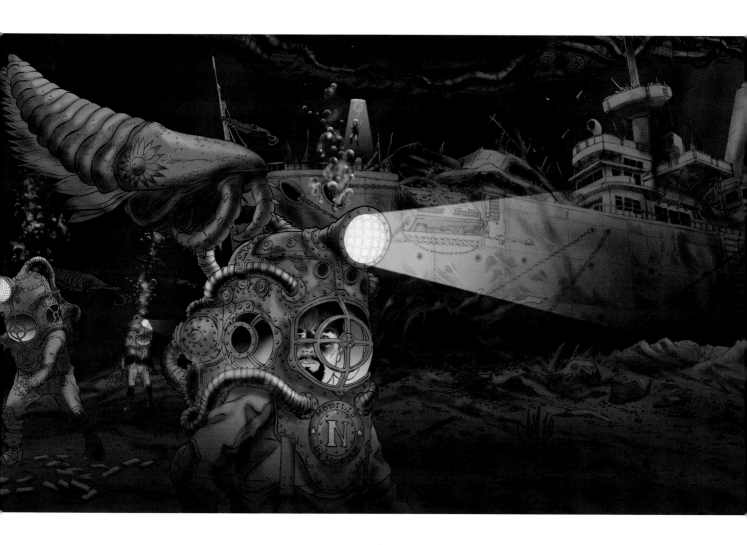

looking for a tiny nugget of gold. I don't think of illustration in terms of inspiration; I think of it in terms of problems, solutions, and ever-diminishing time.

If someone asks me where I get my ideas, I shrug and say, "Oh, I dunno." The truth is that they all finally come from *other artists*—from exposing myself to their work and studying it. This includes the work of comics artists, fine artists and illustrators, and filmmakers. And from studying the world around me, and from just thinking and reading—reading science fiction, history, philosophy, all kinds of things. If you don't know what to draw, throw yourself into the outer world, into any of the things I just mentioned; let yourself be fascinated for a while, and then start putting lines on paper. *Then* ideas will start to flow, and your work will start to come together. You'll be amazed.

It was a tremendous joy producing this book—I hope you enjoyed reading it as much as I enjoyed making it. Best of luck!

INDEX